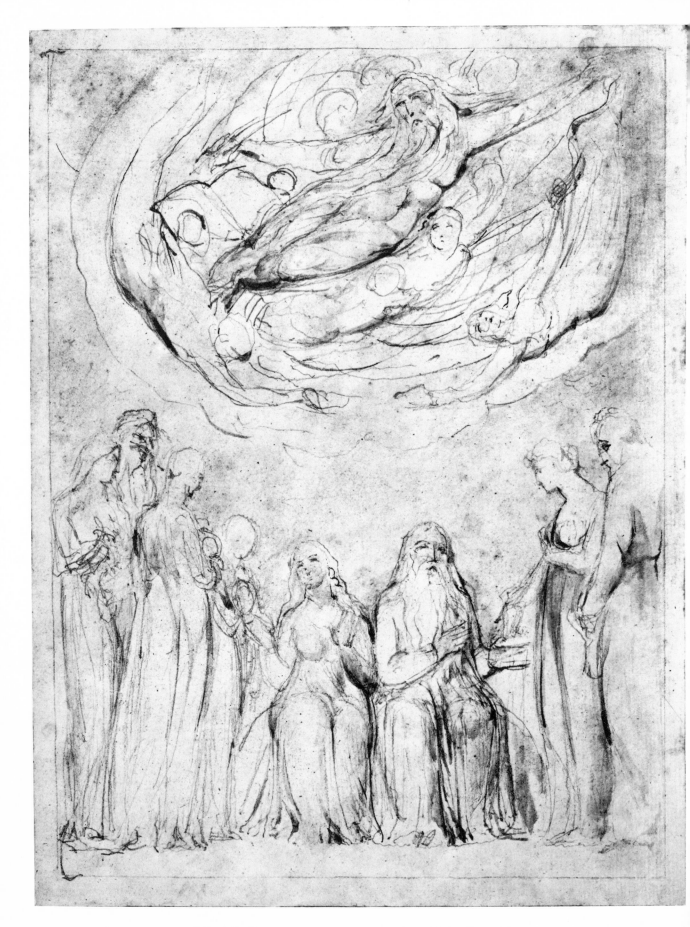

No. 79. Caption appears on same page as caption 80, facing illustration 80.

DRAWINGS OF

WILLIAM BLAKE

92 PENCIL STUDIES

Selection, Introduction and Commentary

by Sir Geoffrey Keynes

CHAIRMAN OF THE WILLIAM BLAKE TRUST OF LONDON

Dover Publications, Inc., New York

Published in Canada by General Publishing Company, Ltd.,
30 Lesmill Road, Don Mills, Toronto, Ontario.
Published in the United Kingdom by Constable and Company, Ltd.,
10 Orange Street, London WC 2.

Drawings of William Blake is a new work, first published
by Dover Publications, Inc., in 1970.

International Standard Book Number: 0-486-22303-5
Library of Congress Catalog Card Number: 71-100545

Manufactured in the United States of America
Dover Publications, Inc.
180 Varick Street
New York, N.Y. 10014

INTRODUCTION

WILLIAM BLAKE entered on his career as draughtsman and artist in 1767 at the age of ten, and for the rest of his life, that is for the next sixty years, never rested from the exercise of his art. His work as journeyman engraver was only the background to his life as creative artist, his output of original work being very large indeed. For most of this he would have used his pencil for laying the foundation of his designs. Seldom would he make a drawing or picture from nature, usually creating his designs out of his head in his workroom. He expressed a dislike for "copying nature," saying that it deadened his imagination, the only true source of creative art. As a boy at his drawing school with Henry Pars in the Strand and later for a short time at the Royal Academy school he must have made drawings from the life and from casts of antique sculpture, but very little evidence of this early work remains. Probably he would not have thought it worth keeping, whereas he would have attached some importance to anything derived from his own mind and imagination.

Samuel Palmer, one of Blake's young disciples in his old age, wrote on one of his drawings that it represented "the first Lines on the preservation of which Mr Blake used so often to insist." It is evident, therefore, that Blake attached a peculiar value to pencil drawings and would be likely to keep in his portfolios, at least for a time, many early studies which other artists would have discarded. He was never tired of asserting that a knowledge of drawing was the one essential in the making of an artist. He recorded his opinion in a forcible form among his annotations to the *Discourses* of Sir Joshua Reynolds. "True!" he exclaimed, when Reynolds said that "A facility of drawing, like that of playing upon a musical instrument, cannot be acquired but by an infinite number of acts." "Good advice!" was his comment on the sentence, "I would particularly recommend that after your return from the Academy . . . you would endeavour to draw the figure by memory." On the other hand, when Reynolds asserted that "the pencil is the instrument by which he [the student] must hope to obtain eminence," Blake answered, "Nonsense!"[1] Drawing was the essential basis of artistic competence, but it was only the basis, not the ultimate means by which the artist became eminent. Drawing was indeed the foundation of everything.

[1] *Blake: Complete Writings*, ed. Keynes, Oxford, 1966, p. 456.

"What does Precision of Pencil mean? If it does not mean Outline, it means Nothing."[2] So it followed that engraving could not be properly executed without knowledge of drawing. It is "drawing on Copper." Similarly "Painting is drawing on Canvas, . . . & Nothing Else."[3]

It is therefore not surprising that Blake, having these strong views on the importance of drawing, did keep a large number of drawings, many of which have survived to the present day. No doubt a much larger number has perished, thrown out by Blake himself, or lost through the carelessness of friends. It would indeed be surprising if Mrs Blake did not sometimes use the apparently less valuable pieces of paper for lighting her fire, or destroy them by cutting them up into patterns in the course of making her and her husband's clothes.

There is no evidence that Blake ever sold his pencil studies and we cannot know how most of his surviving drawings came to be preserved. Some of the earlier pencil drawings have survived owing to their being incorporated in the famous *Notebook*, or *Rossetti MS* as it used to be called, or in the pages of the unfinished manuscript of the long symbolic poem, *The Four Zoas*, both now in the British Museum. Some of the later drawings were certainly given to Blake's friend and benefactor, John Linnell; others were no doubt treasured by his younger friends, Samuel Palmer and George Richmond. A proportion of the later drawings, such as those for the designs illustrating Dante's *Divine Comedy*, came into the possession of Frederick Tatham, who acted as executor for Mrs Blake. It is not unusual to find these sheets inscribed as being Blake's and "vouched by Frederick Tatham."

One well-known category of drawings is fully documented. This comprises the so-called "visionary heads," drawn by Blake from what he claimed were visions of a variety of historical characters who appeared at his command and "sat" for their portraits. The artist and astrologer, John Varley, was greatly interested in this faculty and many of the drawings have been inscribed and sometimes dated by him, the years during which they practised this strange parlour game being 1819 and 1820. It seems clear to me that Varley took this curious pastime a great deal more seriously than did Blake. To the latter it was a satisfaction to employ his faculty of vivid memory and imagination in the production of interesting characterizations of a variety of people, sometimes calling up memories of drawings made when he was an apprentice working for

[2] *Ibid.*, p. 472.
[3] *Ibid.*, p. 594.

his master in Westminster Abbey. Blake sometimes drew them with such conviction that Varley seems to have regarded them as actual portraits. Indeed many of these drawings are fine and powerful works of art, even though some, such as "The Man Who Built the Pyramids" and "The Ghost of a Flea," have become famous partly because they are grotesques.

Although a number of the surviving drawings were clearly studies for finished watercolour or tempera paintings there remain a proportion which are not known to have been used in this way. An example is the very free drawing of Blake's version of the Laocoön group mentioned again later. Parts of this have been carefully worked up as if Blake attached special importance to it, though it is not known to have been carried any further.

At a rough estimate there are perhaps more than two hundred drawings now extant; not all of these are strictly pencil drawings, some being in charcoal or crayon, others having been worked over with the pen or having watercolours added. The present collection of reproductions is arranged in chronological order as far as this can be done, though there must be a considerable element of conjecture.

It was a fortunate thoroughness that prompted Dr Richard Gough, the antiquary, to keep in his albums the drawings of tombs and monuments commissioned by him from James Basire, master engraver, during the time when Blake was one of his apprentices. The story of the boy's quarrels with his fellow apprentices is well known through his friend and first biographer, Benjamin Heath Malkin, who related in the preface to *A Father's Memoirs of his Child*, 1808, how Basire resolved the situation by sending Blake out to work by himself in Westminster Abbey and other churches in and around London. Gough's albums, now in the Bodleian Library, Oxford, contain a number of fine drawings certainly by Blake, two of which, assigned to the year 1774, begin the series of reproductions in this volume (Plates 1 and 2). Blake's early studies of mediaeval art permanently influenced his style and even assumed a place in his symbolic system. He painted a number of designs in illustration of Shakespeare, though few pencil studies for these have survived. One drawing for *Macbeth* is reproduced here (Plate 4). It has the appearance of being an early work, rapidly drawn, though with much dramatic power, and is placed immediately after the drawings of his boyhood. A few more early drawings can be dated by their subjects. One, but little known and never before reproduced (Plate 5), is an illustration of the first symbolic poem, *Tiriel*. Another, "The Penance of Jane Shore" (Plate 3), can be dated by Blake's own reference to the design in his *Descriptive Catalogue*,

1809, as having been made "above Thirty Years ago" and proving to the artist "that the productions of our youth and of our maturer age are equal in all essential points."[4] It is an example of his early aspiration to be a historical painter like some of his contemporaries. We can now see that Blake had gone some way towards establishing his position as a creative artist during his boyhood. On the other hand it has been justly said by Sir Anthony Blunt that had he died at the age of thirty he would not have been remembered as a painter. It was not until about 1787 that his originality began to be plainly seen.

Several of the succeeding drawings (Plates 9 through 15) are taken from the pages of the *Notebook*, while others (Plates 8 and 16) are studies for some of the etched plates in the illuminated books made at Lambeth in the years 1789 to 1794. At about the same period Blake was executing his splendid monotypes or colour prints; the preliminary drawing for one of the finest of these is included here (Plate 18). It represents Sir Isaac Newton as the symbol (for Blake) of materialistic thought and so as the negation of imaginative art. Though Newton represented a phase of the human mind antipathetic to Blake, he has invested the figure with great dignity in this careful and accurate drawing. He sensed, perhaps, that an intellect such as Newton's exercised a kind of imagination in unravelling the laws of nature and so was entitled to respect and even admiration.

Later in the series come several drawings (Plates 24 through 30) taken from the manuscript pages of *The Four Zoas*. These have seldom been reproduced being often difficult to understand. Yet many of Blake's drawings have an intrinsic interest and attraction which does not depend on full comprehension of their meaning. The same can be said of some of his poetry, but this does not exclude it as unworthy of attention. It may be noticed with surprise that so few pencil studies for Blake's numerous illustrations of the Bible have survived, but one at least is included here, a study for the tempera painting of "The Virgin Mary Hushing the Young Baptist" (Plate 34). The massive figure of the Mother seems to brood over her Child while protecting Him from the eager boy with his butterfly. In Blake's mythology female domination was the source of much human error following the Fall of Man, but in the context of this picture it would be wrong to insist on any such interpretation. Soon after this in the series comes Blake's well-known drawing of his faithful wife (Plate 37), assigned conjecturally to the year 1802, when he was living uneasily under the patronage of William Hayley at Felpham. It shows

[4] *Op. cit.*, p. 585.

how competently Blake could turn his hand to portraiture if he chose and how much he depended on Mrs Blake's comforting presence when his other obligations were upsetting his mental composure and creativeness. Associated with this portrait is a landscape drawing (Plate 36) which it is very hard to place. The subject is so unusual with Blake that it is perhaps not unreasonable to guess that living in the country may possibly have inspired him to attempt it.

Soon after his return from Felpham to London Blake was employed in making illustrations for Blair's *The Grave*. These had been commissioned by R. H. Cromek and it was understood that they were also to be engraved by the artist, but in the end Cromek had them executed in a tame conventional style by another hand. The four studies reproduced here (Plates 38 through 41) suggest that Blake would have added much vigour to the engravings if he had been allowed to do so.

An important part of Blake's output were the sets of illustrations he made for Milton's poems—*Paradise Lost, Paradise Regained, Comus,* "L'Allegro," "Il Penseroso" and "On the Morning of Christ's Nativity." A few are reproduced here (Plates 42 through 45 and 49), but again not many of the large number of studies he must have made for them have been preserved. He must also have made many drawings for the hundred plates of *Jerusalem*, the last and greatest of the illuminated books. Those that have survived are particularly fine, as can be seen in the four reproduced here (Plates 53 through 56), but they are all too few. They were made before 1818, the year in which the book was first printed. To this year is also assigned one of the finest pencil drawings Blake ever made. About the year 1815 he had made a conventional drawing from a cast of the "Laocoön" for an engraving commissioned for an encyclopaedia. Two or three years later he made a larger engraving of the subject, adding around it aphorisms concerning his most strongly held religious and artistic beliefs. It was probably about the same time that he drew his own powerful version (Plate 59), transforming the group into a vision of Urizen, the creator of the material world, with his sons, Satan and Adam, struggling with the two serpents, Good and Evil. Although he had put so much feeling and conviction into this drawing Blake never, as far as is known, developed it into any more finished form. It is so fine that perhaps he feared further labouring of the composition might only spoil it. The academic drawing here precedes Blake's anguished version of the human predicament.

It was no doubt about 1819 that Blake made his portrait drawing (Plate 60) of John Varley, with whom he created his "visionary heads"

as already described. The reproductions include a dozen of these curious evidences of his vivid, and often humorous, imagination (Plates 61 through 73).

During the last nine years of his life Blake was saved from serious poverty and neglect by the solicitude and generosity of his young friend, John Linnell, who suggested means of providing him with both occupation and a living, most of the latter coming from Linnell's pocket. The result of this was the engravings for the *Illustrations of the Book of Job*, 1826, and the hundred designs for Dante's *Divine Comedy*. Linnell was aware of the interest and value of the drawings for these projects, with the consequence that many of them have been preserved. A selection from both series is reproduced here (Plates 74 through 80 and 85 through 92) with a few other drawings of about the same period. These include a delightful head of an infant (Plate 81), very possibly one of Linnell's family, whom Blake often visited at their home in Hampstead.

This collection of Blake's drawings has been planned to give a wide view of his competence in this important, because basic, part of his art. Sometimes his "first Lines" were rapidly scribbled as ideas for more finished drawings. Often it is only the more finished versions that remain, though it may be that his imagination worked at different levels at different times. An idea might be so vividly imagined that it had to be dashed off as quickly as possible, or after longer thought was carefully worked out with particular attention to the definite outline by which he set so much store. He could draw with academic accuracy if he chose— this is demonstrated by several careful drawings done late in life from casts of ancient sculpture—or he could introduce deliberate distortions for the sake of emphasis, horror or just eccentricity. His drawings show that this was done in the first flush of creation, not merely added afterwards for effect. He knew what he wanted to do and how to do it. Hesitations are seldom seen in his designs; perhaps it would have been better if he had oftener stopped to think and modify.

In his *Public Address* of about 1810 Blake wrote: "Let a Man who has made a drawing go on & on & he will produce a Picture or Painting, but if he chooses to leave it before he has spoil'd it, he will do a Better Thing."[5] He did not always succeed in producing the "Better Thing," but he would have failed more often if he had tried to exercise too much control over his flowing genius.

Two volumes of reproductions of Blake's pencil drawings were published by the Nonesuch Press, London, under my editorship in 1927 (*Pen-*

[5] *Op. cit.,* p. 603.

x

cil Drawings by William Blake) and 1956 (*Blake's Pencil Drawings; Second Series*); these contained a total of 138 subjects, but included one wrongly attributed, one repetition and five plates of small designs which were in fact sepia, not pencil, drawings. The present collection has 92 subjects; the majority of these appeared in the earlier volumes, with a few reproduced for the first time. I am indebted to various institutions in Great Britain and the United States of America for permission to use their drawings and to many private owners, whose names are recorded after the titles of the subjects. The publishers join with me in offering them our grateful thanks for their generosity.

1970 GEOFFREY KEYNES

LIST OF ILLUSTRATIONS

DRAWINGS OF

WILLIAM

BLAKE

1 Queen Eleanor, from Her Monument in Westminster Abbey

1774; 336 × 295 mm. (Bodleian Library, Oxford)

The Queen, wife of Edward I, was drawn from her monument when Blake was working as an apprentice to a master engraver, James Basire. If the drawing was signed, it was the master who put his name to it, as in this one—"J Basire del." Blake also made an engraving of the subject for Gough's *Sepulchral Monuments of Great Britain*, Part I, London, 1786.

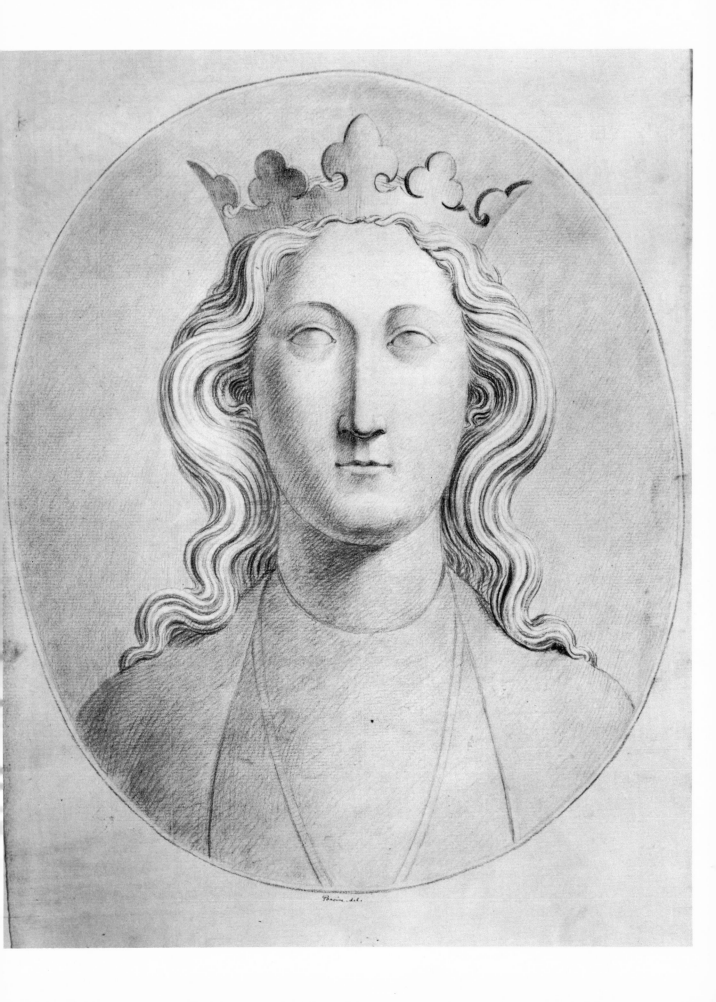

2 King Edward III, from His Monument in Westminster
Abbey

1774; 345 × 295 mm. (Bodleian Library, Oxford)

Drawn by Blake in Westminster Abbey when working as an apprentice
for James Basire, master engraver. Blake also made an engraving of the
subject for Gough's *Sepulchral Monuments of Great Britain*, Part I,
London, 1786.

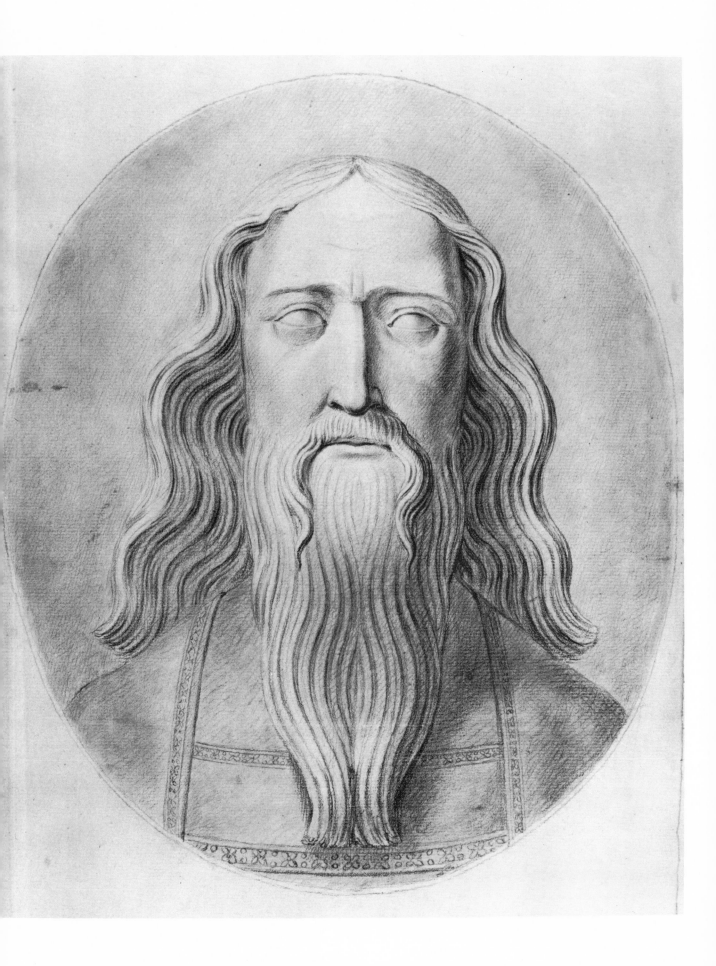

3 The Penance of Jane Shore

c. 1778; 320 × 485 mm. (Sir Geoffrey Keynes Collection)

A pencil study for the early watercolour painting in the Tate Gallery, London. Jane Shore, mistress of King Edward IV, was made to do penance in St Paul's Church after the King's death. Blake wrote of this composition in his *Descriptive Catalogue*, 1809: "This Drawing was done above Thirty Years ago, and proves to the Author . . . that the productions of our youth and of our maturer age are equal in all essential points."

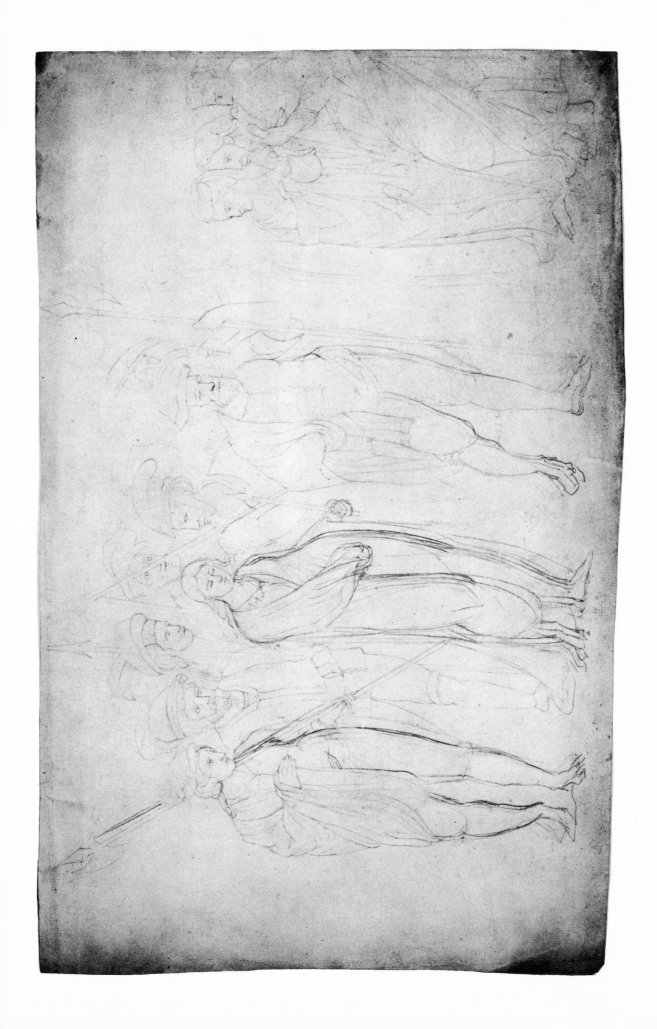

4 Macbeth and the Ghost of Banquo

c. 1785 (?); 360 × 510 mm. (Sir Geoffrey Keynes Collection)

A large and rough sketch of a Shakespearean subject, not taken any further as far as is known; probably an early work.

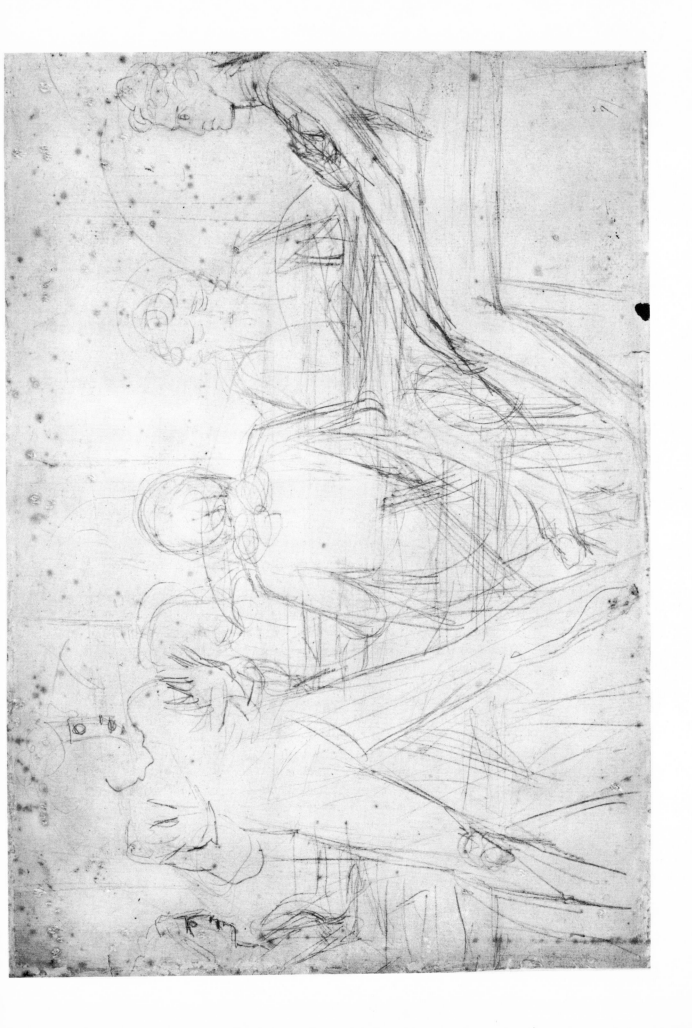

5 "Why is one law given to the lion & the patient Ox?"

c. 1788; 200 × 259 mm. (Professor C. A. Ryskamp, Princeton, N.J.)

This early drawing is on the other side of the sheet carrying the somewhat later studies of human limbs (Plate 16). It is clearly a tentative idea for an illustration to Blake's first symbolic poem, *Tiriel*, c. 1789. The scene shows the lion lying down with the patient ox; behind them is the rather comically horrible figure of the blind tyrant Tiriel with his whip. The quotation given as the title of the design is from *Tiriel*, line 360. A boy apparently holding a book is lying on the lion's back; a girl with a lyre leans against the ox, her left hand resting on the boy's shoulder. These two figures probably represent Har and Heva, who were, in fact, Tiriel's parents, but so senile that they are drawn here (and elsewhere) as children, symbolizing the decadent poetry and music of Blake's time. His illustrations for *Tiriel*, of which twelve are known, do not illustrate the text literally, and the present design is allusive rather than illustrative.

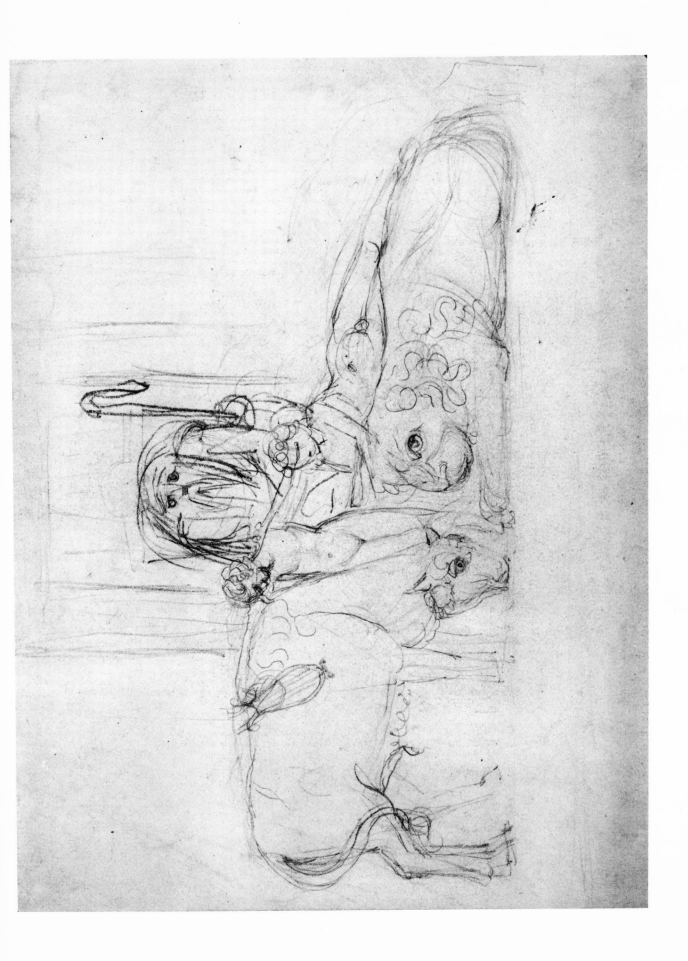

6 God Creating the Universe

c. 1788; 228 × 318 mm. (Collection of Mr and Mrs Paul Mellon, Washington, D.C.)

A pencil drawing partly inked over or redrawn. The Creator is crouching on one knee with his compasses drawn in two positions. Inscribed, not in Blake's hand: "When he prepared the heavens, I was there, when he set a compass upon the face of the depth. Proverbs Chap. 8 v. 27." The design was used for the unique print in the series, *There is No Natural Religion*, c. 1788, where it represents the rational man gazing at the ground and seeing himself only. The subject is not entirely original, having been adapted, as first noticed by Mr Michael Phillips, from the engraved frontispiece for Hervey's *Meditations among the Tombs*, vol. II, third edition, 1748.

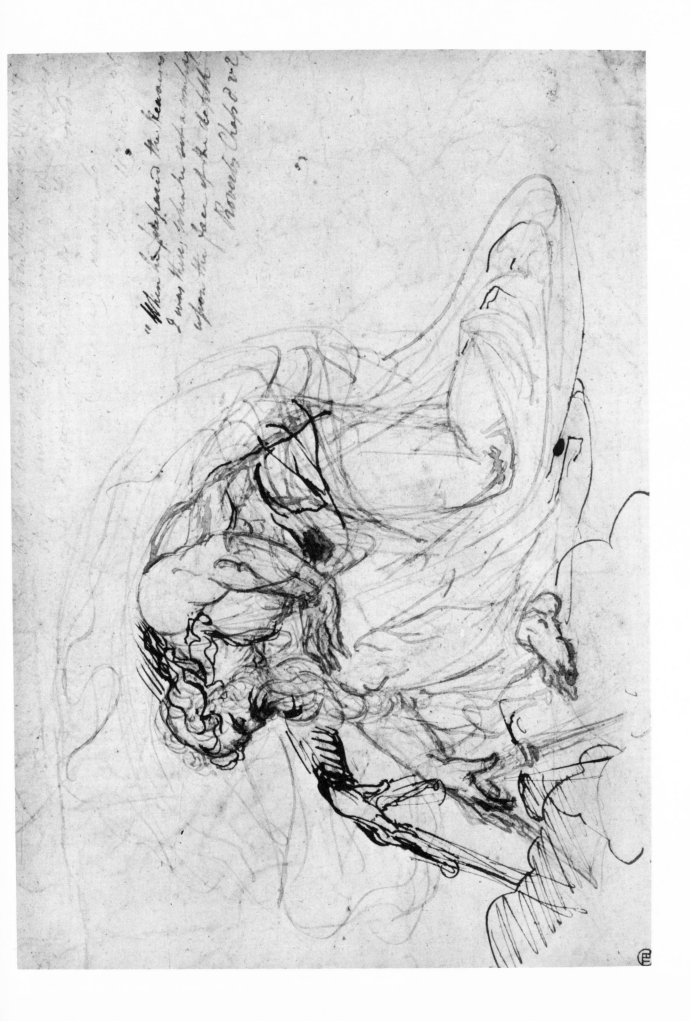

"When he appeared the heavens
I was there; when he set a compass
upon the face of the depth."
Proverbs Chap 8 v 2

7 An Historical Scene, unidentified

c. 1788; 280 × 390 mm. (National Gallery of Art, Washington, D.C.,
Lessing J. Rosenwald Collection)

In the centre an old man with a book between his knees is seated arguing
with two men in monkish habits. On the left a thickset man watches the
scene, leaning on a sword. On the right three men are listening to the
argument. Possibly a design for Joseph of Arimathea visiting Britain.

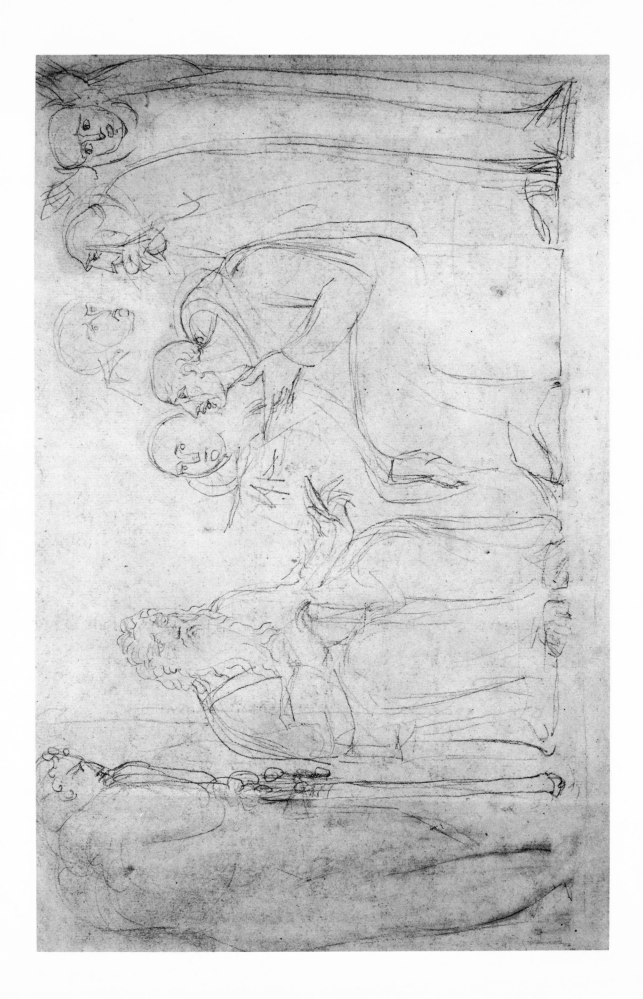

8 War and the Fear of Invasion

c. 1790; 200 × 273 mm. (Whitworth Art Gallery, Manchester, England)

In its first form the design did duty as an illustration to the early symbolic poem, *Tiriel*, representing Tiriel cursing his sons and daughters. Later the three figures on the right were engraved as a group symbolizing War. Later still, in 1793, the left-hand group was adapted as an illustration for the illuminated book *Europe*, showing an old man repelling invasion.

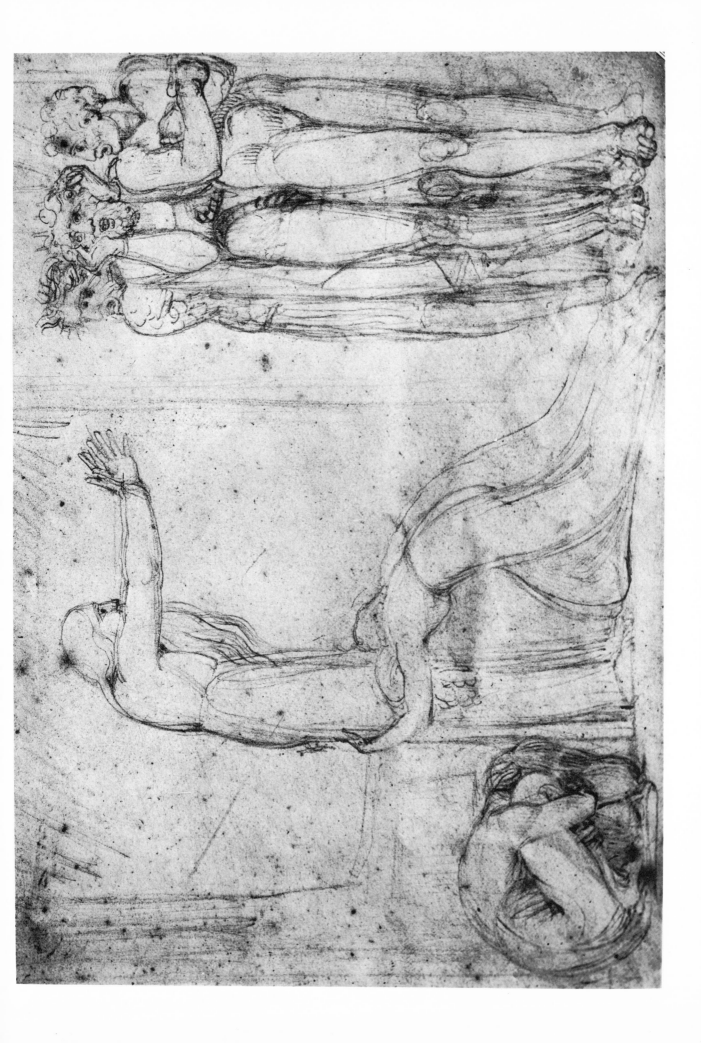

9 Nebuchadnezzar

c. 1790; 195 × 155 mm. (British Museum, Department of Manuscripts)

A pencil study for the subject etched in reverse on Plate 24 of *The Marriage of Heaven and Hell*, c. 1790, and used again in the large coloured monotype, c. 1793, of which one example is in the Tate Gallery, London. From Blake's MS *Notebook*, p. 44.

Let a Man who has made a Drawing ~~go~~ on & on & he will
produce a Picture or Painting but if he chooses to leave off
before he has spoild it he will ⊕ do a Better Thing

10 The Traveller

c. 1793; 195 × 155 mm. (British Museum, Department of Manuscripts)

A pencil study for Plate 14 of *The Gates of Paradise*, 1793, a book of emblems; inscribed below, "The Traveller hasteth in the Evening," and numbered 39. Surrounding this study are smaller sketches—on the right, three ideas for a bearded monster floating in the air with a human body held in its mouth; on the left a man relieving himself, and a man looking down at a dog. From Blake's MS *Notebook*, p. 15.

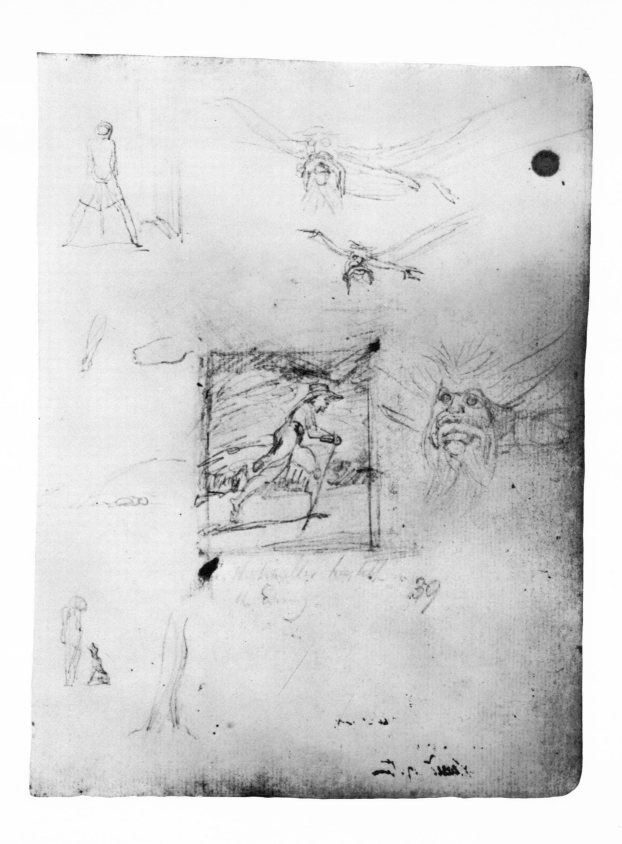

11 Various Studies, unidentified

c. 1793; 195 × 155 mm. (British Museum, Department of Manuscripts)

Above are two further studies of the floating monster as in Plate 10. Below is a nude man seen from behind, and a group of a woman with three children. From Blake's MS *Notebook*, p. 16.

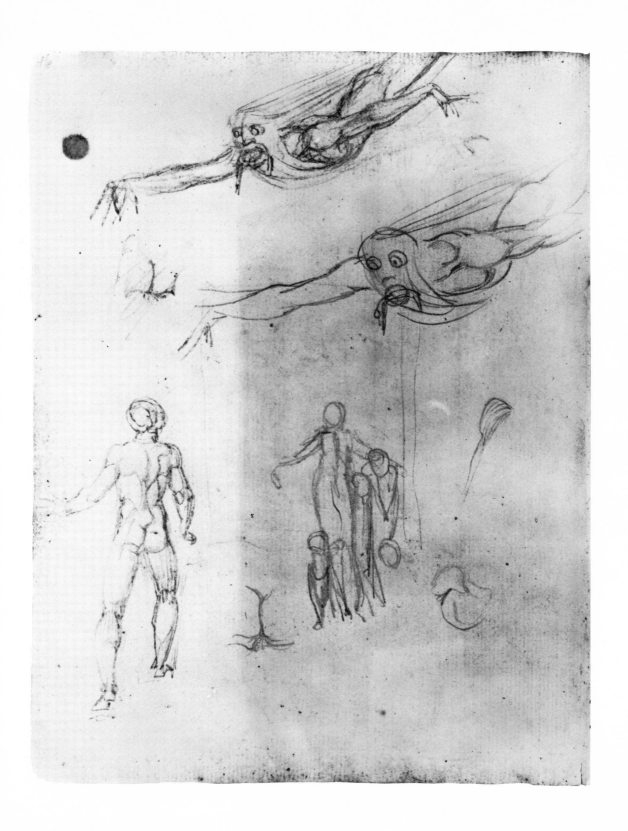

12 Oothoon Plucking the Marigold of Leutha's Vale

c. 1793; 195 × 155 mm. (British Museum, Department of Manuscripts)

A pencil study of a kneeling woman kissing a small flying figure as it springs from a flower. The subject was etched on Plate iii of the illuminated book *Visions of the Daughters of Albion*, 1793. From Blake's MS *Notebook*, p. 28.

Sir Joshua Praises Michael Angelo.
'Tis Christian Mildness when Knaves Praise a Foe
But 'twould be Madness all the World would say
Should Michael Angelo praise Sir Joshua
Christ used the Pharisees in a rougher way

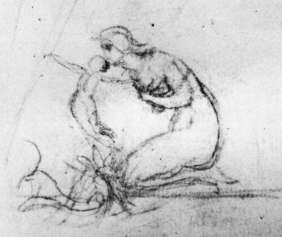

He's a Blockhead who wants a proof of what he can't Perceive
And he's a Fool who tries to make such a Blockhead believe

13 God Creating Adam

c. 1793; 195 × 155 mm. (British Museum, Department of Manuscripts)

A pencil study for the large coloured monotype, c. 1793, in the Tate Gallery, London. In the centre of the page is a sketch of a child leading an old man supported on sticks as in "London," *Songs of Experience*, 1794, Plate 46. Near the top is a drawing of a man's head in profile. From Blake's MS *Notebook*, p. 54.

And take Revenge at the Last Day Jesus wept & thunder hurld
This Corporeal Life a fiction I never will Pray for the World
And is made up of Contradiction Once a did so when I prayd in the Garden
Can that which was of woman born I wishd to take with me a Bodily Pardon
In the absence of the Morn
When the Soul fell into Sleep
And Archangels round it weep
Shooting out against the Light
Fibres of a deadly night
Reasoning upon its own dark Fiction
In doubt which is Self Contradiction
Humility is only doubt
And does the Sun & Moon blot out
Rooting over with thorns & stems
The buried Soul & all its Gems
This Life's dim Windows of the Soul
Distorts the Heavens from Pole to Pole
And leads you to Believe a Lie
When you see with not thro the Eye
That was born in a night to perish in a night
When the Soul Slept in the beams of Light 298 lines

Was Jesus Chaste or did he &c

Im Sure This Jesus will not do
Either for Englishman or Jew

14 Adam and Eve

c. 1793; 155 × 195 mm. (British Museum, Department of Manuscripts)

A pencil drawing of two nude figures hand in hand, from Blake's MS *Notebook*, p. 102. It was not used in quite this form in any other composition.

15 The Trinity

c. 1793; 155 × 195 mm. (British Museum, Department of Manuscripts)

God the Father receives God the Son; the Holy Ghost floats over them. Probably a first idea for the later watercolour drawing of "The Father and the Son" for the *Paradise Lost* series, Boston Museum of Fine Arts, no. 3, 1808. From Blake's MS *Notebook*, p. 104.

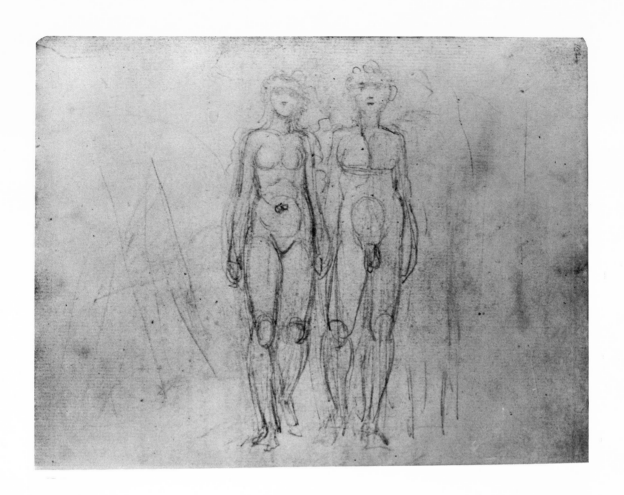

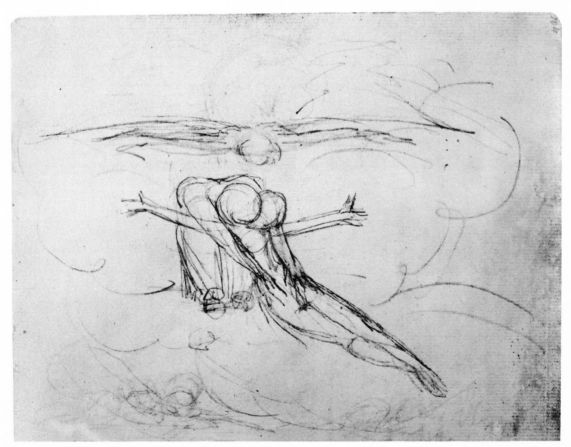

16 Studies of Human Limbs

c. 1793; 200 × 259 mm. (Professor C. A. Ryskamp, Princeton, N.J.)

These studies of human limbs, particularly of the hands and feet, are typical of Blake's work and can be matched in many of his drawings, the earliest being the sketchbook of 1777–8 used for teaching his young brother, Robert, to draw (Henry E. Huntington Library and Art Gallery). The two figures of a floating man with broken chains trailing from his arms and of a running woman were used in Plate 1 of the illuminated book *America, a Prophecy*, 1793–4. The man typifies America released by revolution; the woman is fleeing from the flames of war. The early drawing, Plate 4, is on the other side of the sheet.

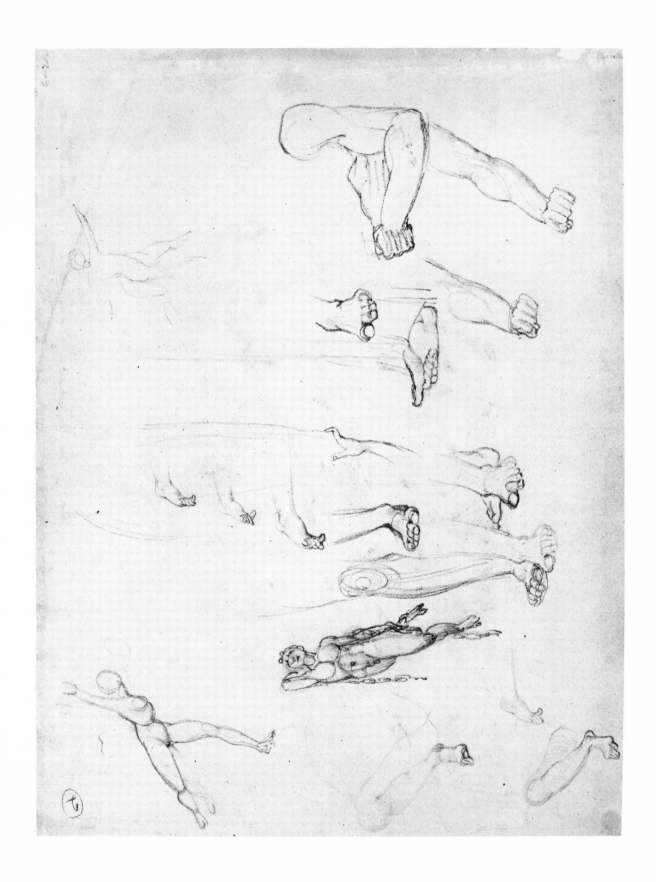

17 Joseph of Arimathea Preaching to the Inhabitants of Britain

c. 1794; 343 × 490 mm. (Philip H. and A. S. W. Rosenbach Foundation, Philadelphia, Pa.)

Joseph of Arimathea was, according to legend, the first man to preach the Gospel of Christ at Glastonbury in Britain. This drawing was adapted for a coloured monotype made in 1794.

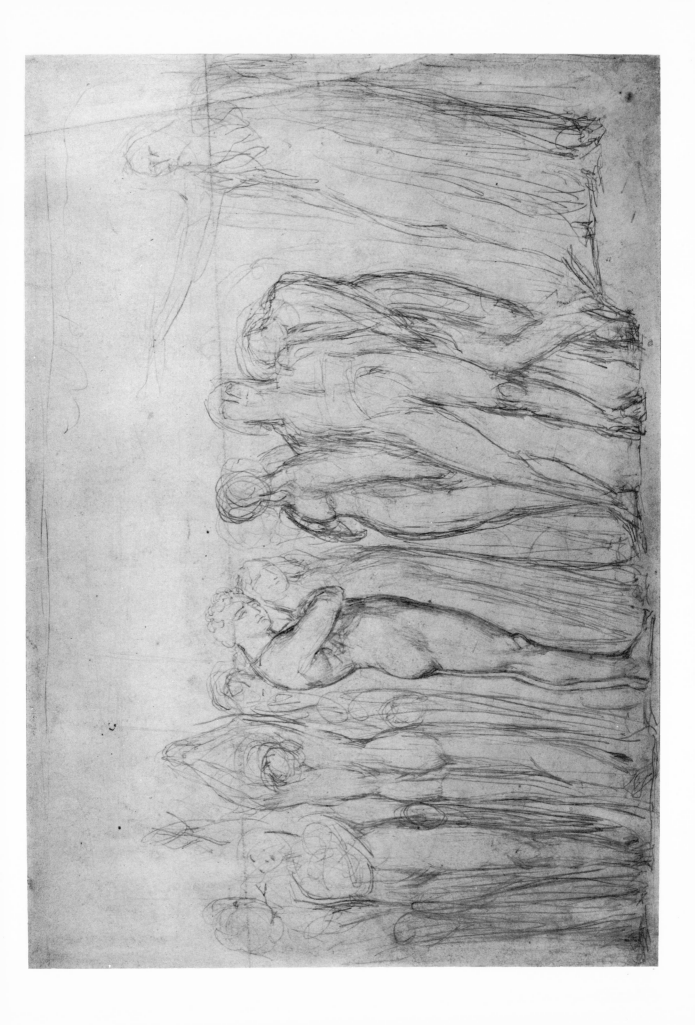

18 Sir Isaac Newton

c. 1795; 200 × 260 mm. (Sir Geoffrey Keynes Collection)

A pencil drawing in reverse for the coloured monotype, one example of which is in the Tate Gallery, London. In the print the rock forming Sir Isaac's seat has on its surface anemones and seaweed; these, which do not appear in the drawing, indicate that he is sitting at the bottom of the sea, water being the symbol of his materialistic philosophy.

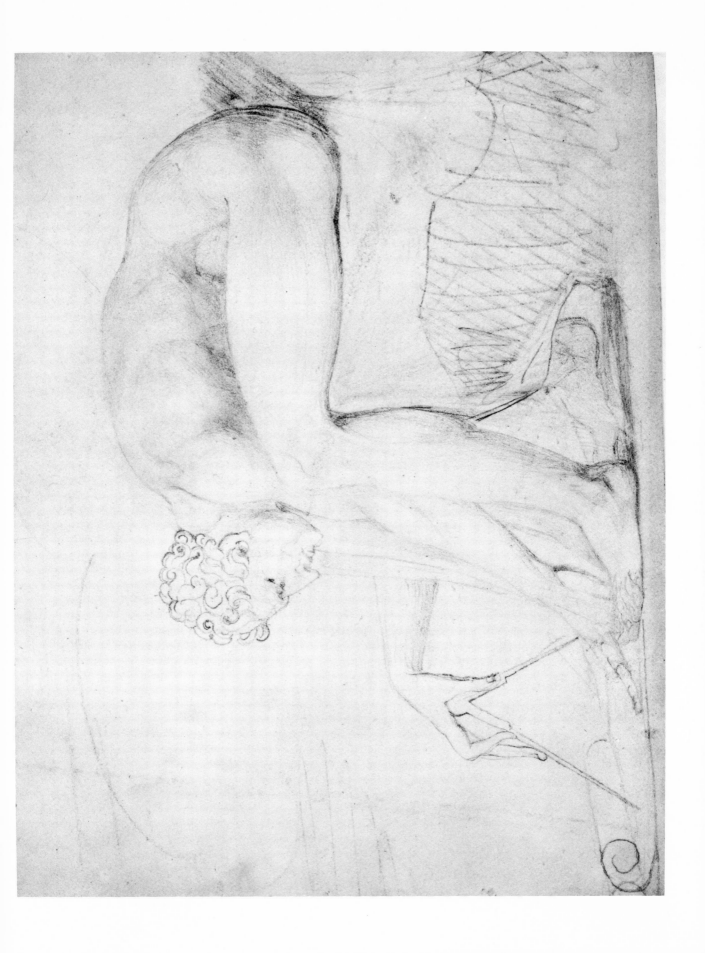

19 The Triple Hecate

c. 1795; 240 × 280 mm. (Private collection, England)

A pencil study in reverse, with slight colouring added, for the large coloured monotype now in the Tate Gallery, London. The Triple Hecate, an infernal Trinity, crouches in the centre. An evil winged spectre hovers over her. On her left an ass is grazing on rank vegetation, while an owl and a great toad watch from between rocks. The theme of the Moon Goddess is derived from Shakespeare's *Midsummer Night's Dream*.

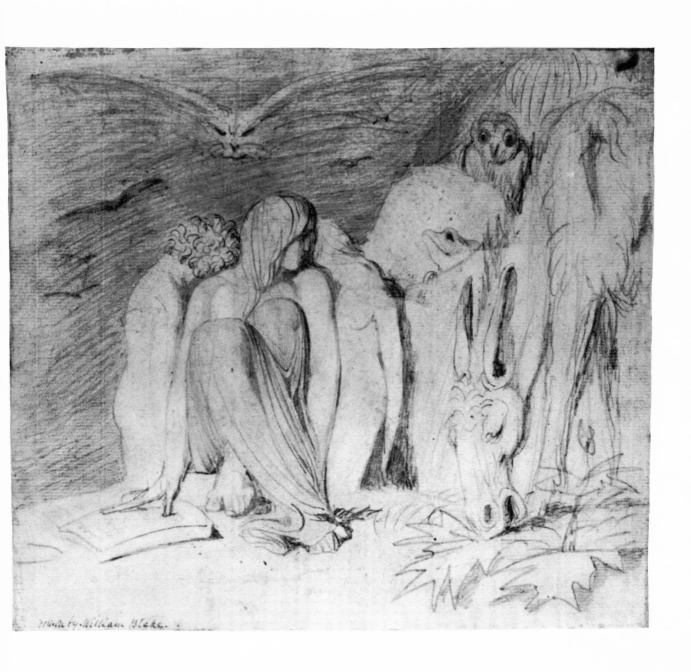

drawn by William Blake.

20 Urizen and Ahania

c. 1795; 160 × 130 mm. (British Museum, Department of Prints and Drawings)

Urizen, the tyrannical creator of the material world, is crushing with his massive hands his Emanation, Ahania, kneeling between his legs. She at first symbolized Enjoyment, but came to be regarded as Sin and was therefore hidden away by Urizen. The drawing was used as a study for the colour-printed frontispiece of the unique copy of the illuminated book *The Book of Ahania*, 1795, now in the Lessing J. Rosenwald Collection, National Gallery of Art, Washington, D.C.

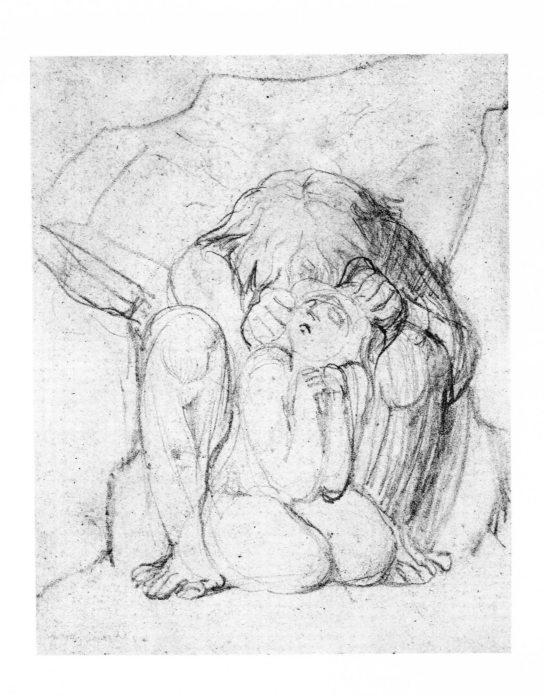

21 Urizen Scattering His Thunderbolts

c. 1795; 45 × 220 mm. (Victoria and Albert Museum, London)

A frieze showing a bearded god of terror scattering his flaming thunderbolts over human beings on either side. This image of a vengeful Deity is found in others of Blake's designs, notably in the coloured monotype of "The Lazar House" (Tate Gallery, London), where he presides over a scene of death and despair.

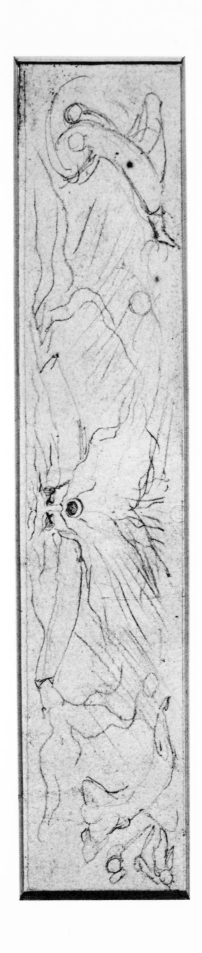

22 Warring Angels

c. 1796; 250 × 300 mm. (British Museum, Department of Prints and Drawings)

A somewhat mutilated pencil sketch for the watercolour illustration no. 52 for Young's *Night Thoughts*, 1796–7. This Miltonic subject may be interpreted as Michael with a sword attacking Satan, who is falling back with other figures behind him.

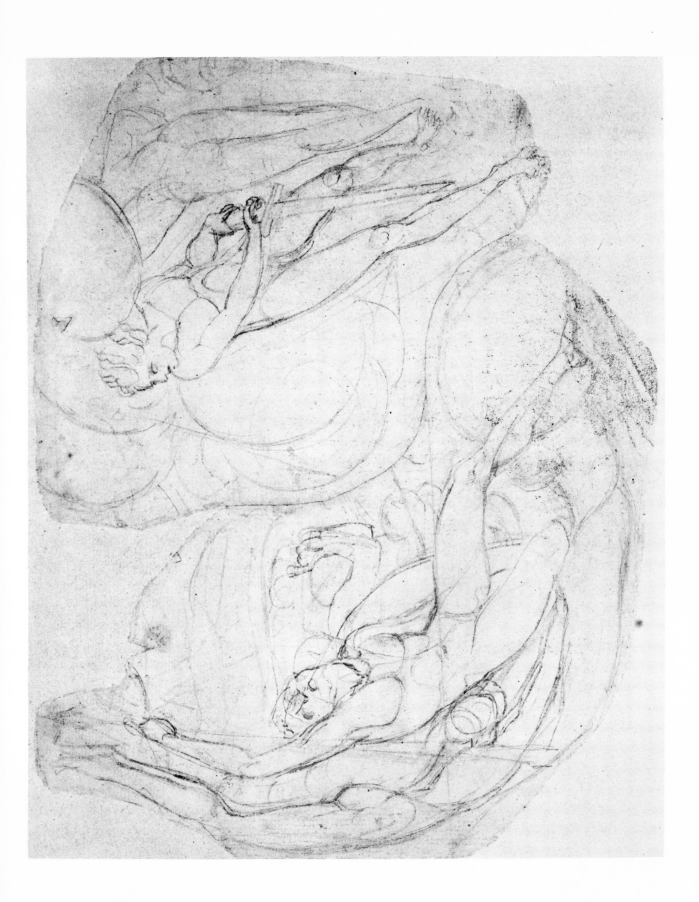

23 "The thought of death alone the fear destroys"

c. 1797; 170 × 308 mm. (The Cleveland Museum of Art, gift of the Print Club of Cleveland)

A shepherd, with his crook resting against a rock and with his dog at his feet, is seated above a precipice and appears to be about to fall over the edge. The drawing is a study for one of the series of illustrations for Young's *Night Thoughts*.

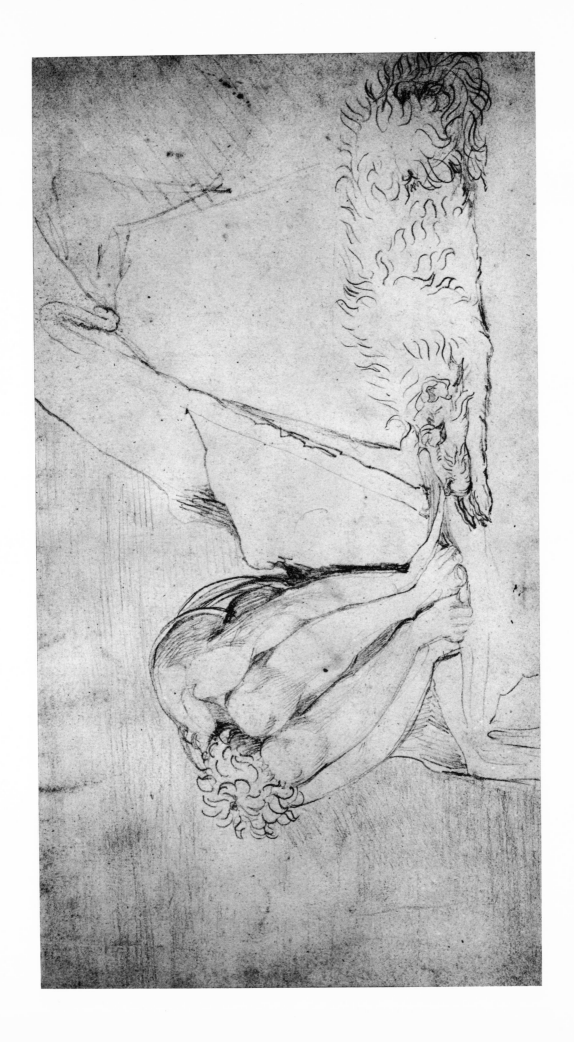

24 Dragon Forms

c. 1797; 194 × 320 mm. (The British Museum, Department of Manuscripts)

A pencil drawing illustrating *Vala, or The Four Zoas*, from p. 26 of the MS, Night the Second, line 89, "Till she became a Dragon, winged, bright & poisonous"; perhaps related also to Night the Fourth, line 24, "Deform'd I see these lineaments of ungratified desire."

25 Albion and Rahab

c. 1797; 180 × 320 mm. (The British Museum, Department of Manuscripts)

A pencil drawing on p. 27 of the MS of *Vala, or The Four Zoas*. The emaciated form of Albion, or England, draws a veil from a smiling woman, Rahab, the Whore of Babylon. Not obviously related to any line on this page.

And I commanded springs to rise for her in the black desart
Till she became a dragon winged bright & poisonous
I opend all the floodgates of the heavens to quench her thirst

And

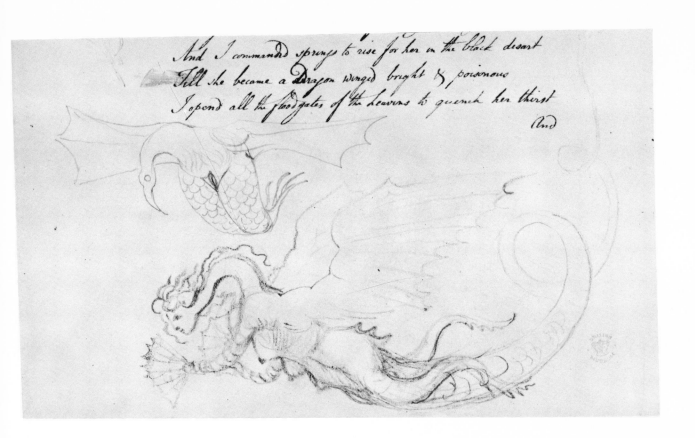

That Human delusion to deliver all the sons of God
From bondage of the Human form, O first born Son of Light
O Urizen my enemy I weep for thy stern ambition
But weep in vain O when will you return Vala the wanderer

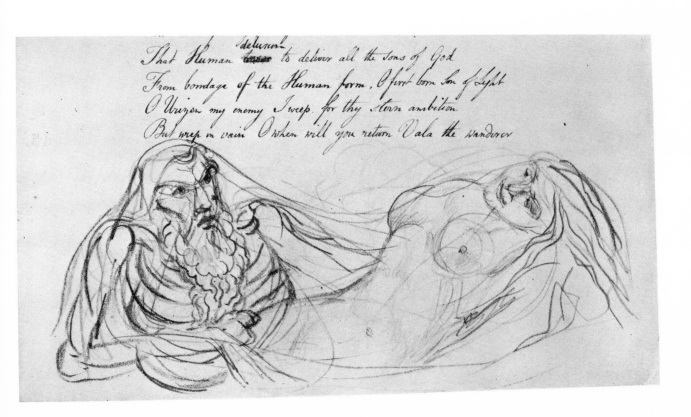

26 The Jealousy of Los

c. 1797; 240 × 320 mm. (The British Museum, Department of Manuscripts)

A pencil drawing with crayon background. It shows Los kneeling with a cord round his bosom and looking over his shoulder at Orc embracing Enitharmon, Orc's mother. The subject illustrates *Vala, or The Four Zoas*, MS p. 60, Night the Fifth, lines 79–84:

> But when fourteen summers & winters had revolved over
> Their solemn habitation, Los beheld the ruddy boy
> Embracing his bright mother, & beheld malignant fires
> In his young eyes, discerning plain that Orc plotted his death.
> Grief rose upon his ruddy brows; a tightening girdle grew
> Around his bosom like a bloody cord . . .

27 The Shadow of Enitharmon

c. 1797; 175 × 320 mm. (The British Museum, Department of Manuscripts)

A pencil drawing with a crayon background. The subject, Enitharmon holding a hoop set with eight stars, has only a general relation to the text of the page where it is drawn, in *Vala, or The Four Zoas*, Night the Seventh, MS p. 82.

Enitharmon beheld the bloody chain of nights & days
Depending from the bosom of Los & how with dismal pains
He went each morning to his labours with the spectre dark
Calld it the chain of Jealousy. Now Los began to speak
His woes aloud to Enitharmon. since he could not hide
His uncouth plague. He seizd the boy in his immortal hands
While Enitharmon followd him weeping in dismal woe
Up to the iron mountains top & there the jealous chain
Fell from his bosom on the mountain. The spectre dark 100
Held the fierce boy Los naild him down. binding around his limbs
The dismal chain O how bright Enitharmon howld & cried
Over her Son. Obdurate Los bound down her loved Joy

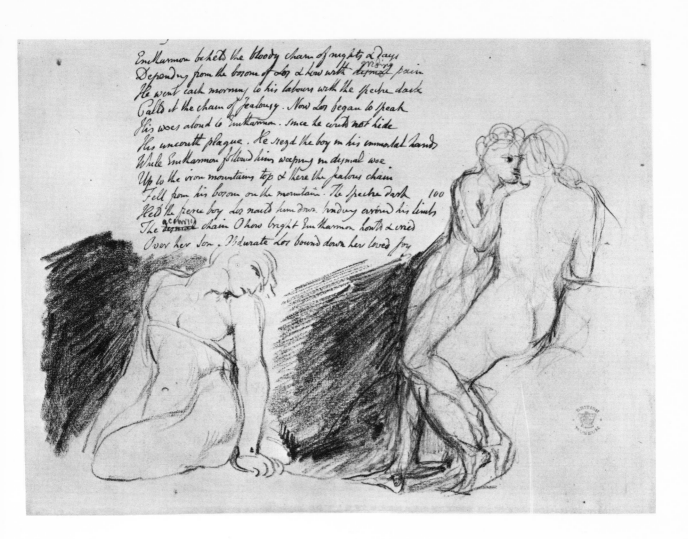

"Because of Orc because he rent his discordant way
From thy sweet loins of bliss. red flowd thy blood
Pale grew thy face lightnings playd around thee thunders hovered
Over thee; & the terrible Orc rent his discordant way
But the next joy of thine shall be in sweet delusion
And its birth in fainting & sleep & sweet delusions of Vala

The Shadow of Enitharmon answerd Art thou terrible shade
Set over this sweet boy of mine to guard him lest he rend

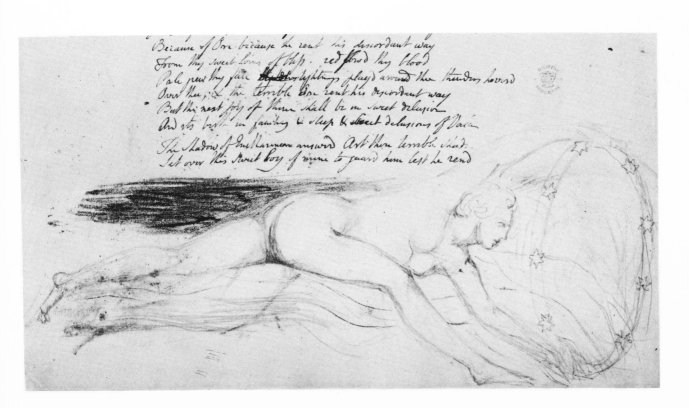

28 Five Nude Forms

c. 1797; 410 × 320 mm. (The British Museum, Department of Manuscripts)

The central figure seen from behind probably represents Los balancing the globe of the sun on his head. Male figures float on either side of him; two women are seated below. The drawing is on MS p. 66 of *Vala, or The Four Zoas*, Night the Fifth, a page without text.

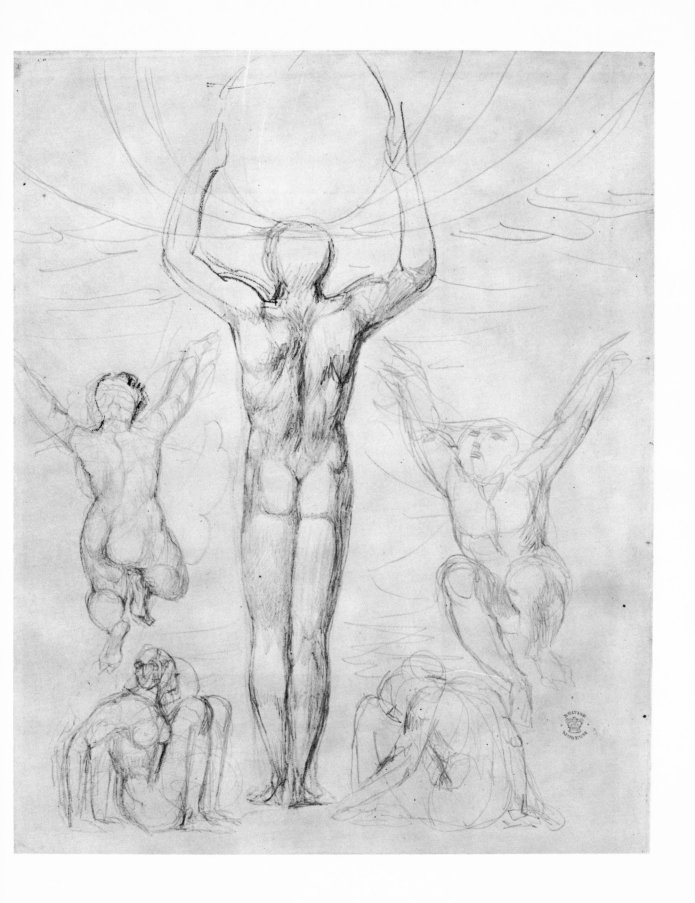

29 Enitharmon Kneeling

c. 1797; 340 × 320 mm. (The British Museum, Department of Manuscripts)

A large pencil drawing with crayon background in the centre of MS p. 86 of *Vala, or The Four Zoas*, Night the Seventh [a]. It has no obvious relation to the text.

...me & thou annihilate evaporate & be no more
For thou art but a form & organ of life & thyself
Art nothing being created continually by Mercy & Love divine

Los furious answerd. Spectre horrible thy words astound my Ear
With irresistible conviction I feel I am not one of those
Who when convinced can still persist. tho furious. controllable
By Reasons power. Even I already feel a World within
Opening its gates & in all the real substances

30 Jesus Parting the Clouds

c. 1797; 410 × 320 mm. (The British Museum, Department of Manuscripts)

A large pencil drawing occupying the greater part of MS p. 116 of *Vala, or The Four Zoas*, Night the Eighth. It has no obvious relation to the text.

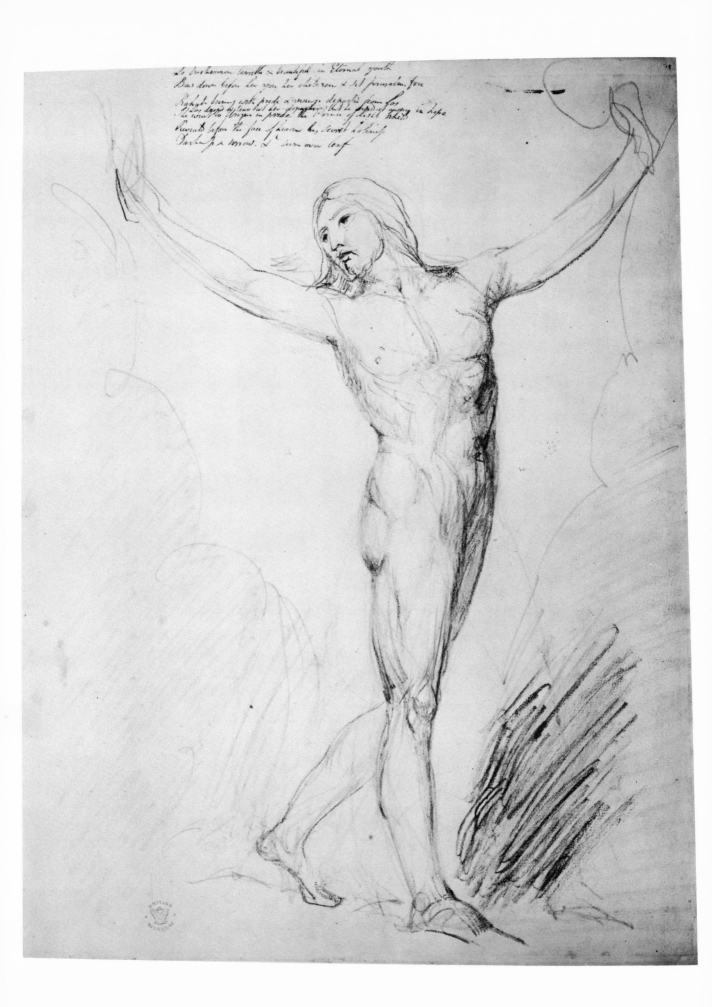

31 Allegorical Design with a River God

c. 1800; 190 × 355 mm. (Victoria and Albert Museum, London)

This complicated design has not been elucidated or identified with any similar composition. A river god, resting his left arm on a culvert, looks benevolently on a woman floating with outstretched arms in the water. A spirit plunges out of the clouds to clasp her head. A demonic figure on the left turns his head to watch, raising his hands in fear. The detail of the river god was used in Blake's fourth design for Gray's "Ode on a Distant Prospect of Eton College," where a bathing schoolboy replaces the woman.

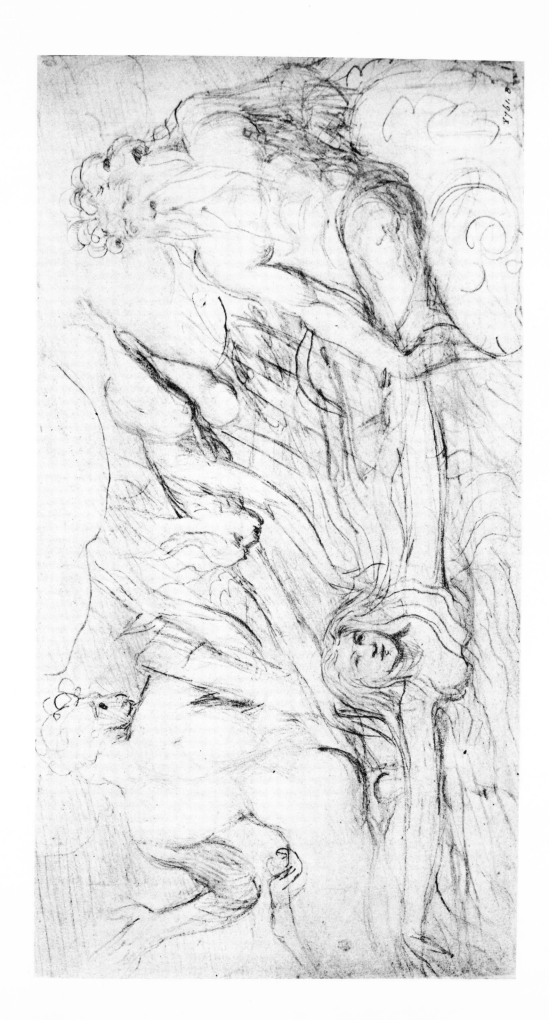

32 Nude Male Figures

c. 1800; 133 × 215 mm. (Philip H. and A. S. W. Rosenbach Foundation, Philadelphia, Pa.)

These studies of contorted figures have not been identified in any other compositions.

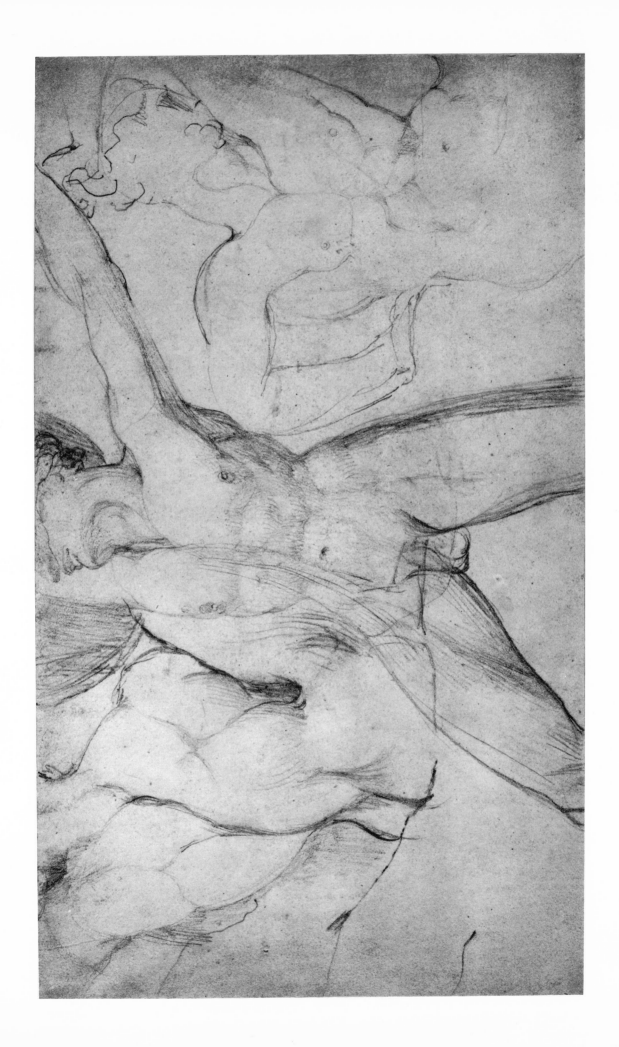

33 The Bowman and the Spirit of Inspiration

c. 1800; 190 × 216 mm. (Sir Geoffrey Keynes Collection)

A pencil drawing perhaps illustrating the lines in the Preface to Blake's *Milton* beginning "Bring me my Bow of burning gold." The figure of the Bowman was used in the sixth illustration to Gray's poem, "The Progress of Poesy," now in the Paul Mellon Collection, for the line, "Hyperion's march they spy, and glittering shafts of war." In the Gray illustration it is considerably altered and the Spirit does not appear, the Bowman having become a symbol of war.

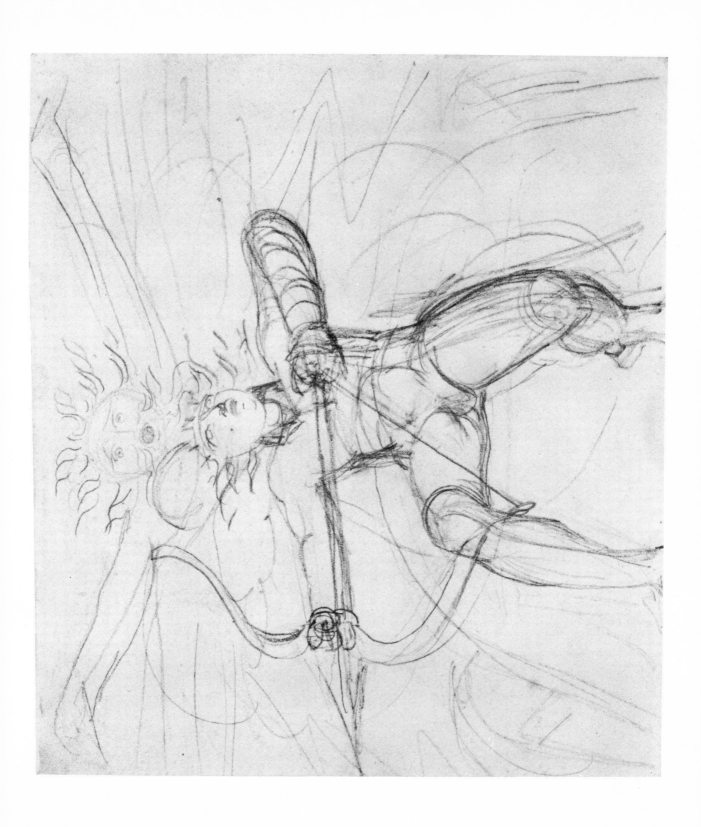

34 The Virgin Mary Hushing the Young Baptist

c. 1800; 270 × 385 mm. (Sir Geoffrey Keynes Collection)

A pencil drawing on tracing paper for the tempera painting now in a
private collection in the United States. The infant Christ is lying asleep on
a bed watched by His Mother; she admonishes the young St John
approaching from the right with a butterfly in his hand.

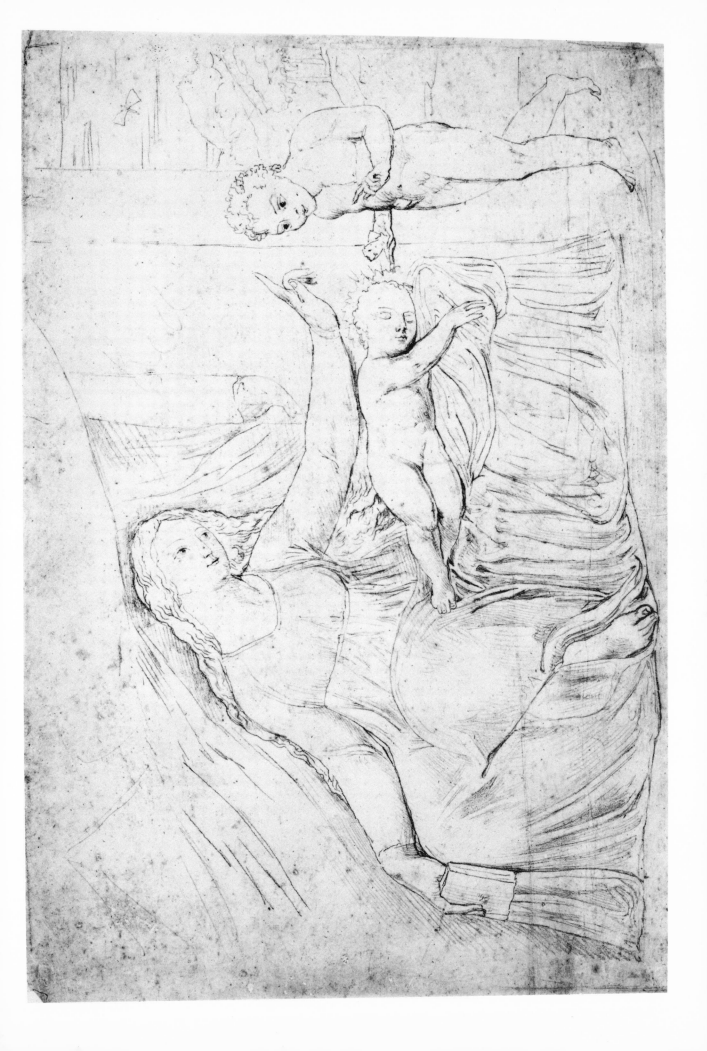

35 Unidentified subject, known as The Death Chamber

c. 1800–1805; 250 × 315 mm. (Sir Geoffrey Keynes Collection)

A pencil study for an unidentified subject, perhaps a sacrificial scene, since in another version in red crayon, now in the Philadelphia Museum of Art, the women in the background appear to be taking burning brands from an altar. The contorted figure in the centre was used by Blake in his watercolour painting known as "The Stoning of Achan," or "The Blasphemer," in the Tate Gallery, London.

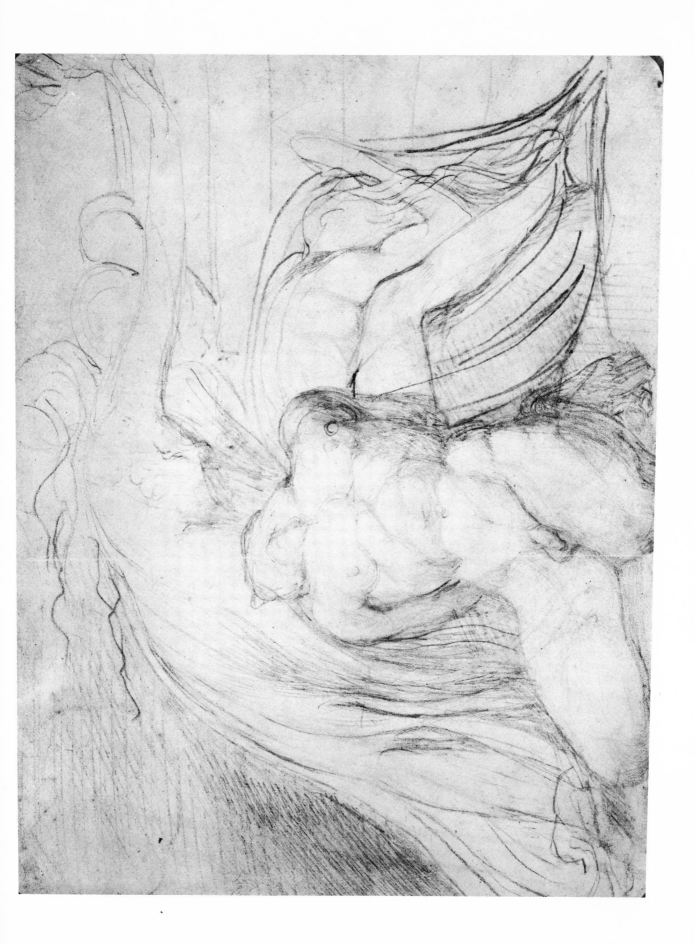

36 Landscape with Trees

c. 1800–1803 (?); 153 × 225 mm. (present owner not known)

The number of known landscape sketches by Blake is very small. The one reproduced here is the only one in pencil, three others being in pen or watercolour. It shows parkland with trees and, in the distance, a church spire. A subject of this kind is so unusual with Blake that it could not be identified as his if it had not been certified by Frederick Tatham, whose inscription is seen below. There is no means of determining the date when it was done, though it is possible that all the landscape drawings were made when Blake was living in Sussex, 1800–1803.

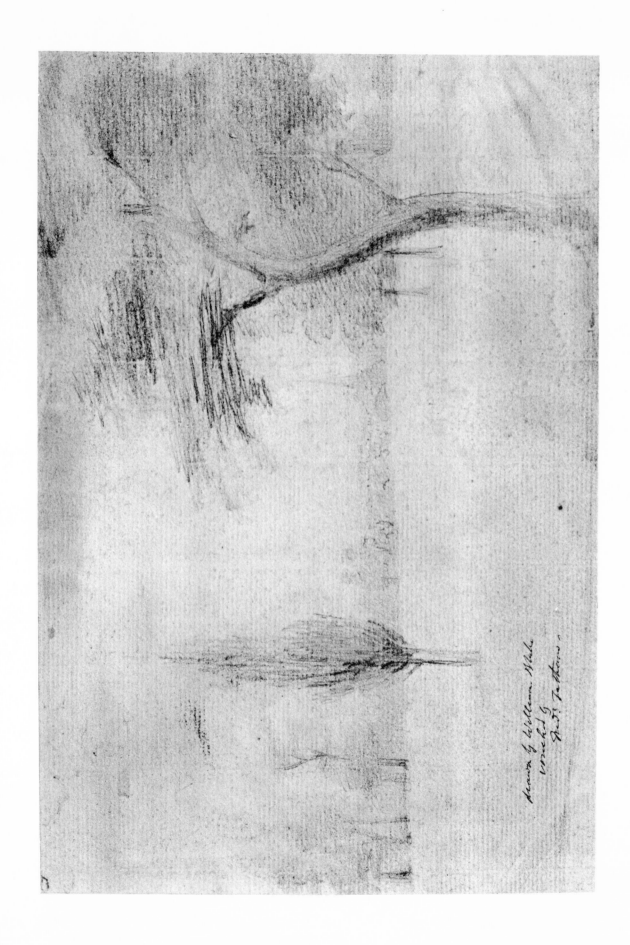

Drawn by William Wells
etched by
F.J. Tatham

37 Portrait of Catherine Blake

c. 1802; 255 × 200 mm. (Tate Gallery, London)

A sketch of Mrs Blake in middle life, looking down at her hands busied with knitting or sewing. The drawing is on the verso of a proof page of Hayley's *Ballads*, 1802, the printed letters of which show through the paper. It was probably done at this time. Inscribed "Catherine" at the lower right-hand corner, and "Mrs Blake/Drawn by Blake" by Frederick Tatham in the centre.

Mrs Blake
drawn by Blake

38 The Meeting of a Family in Heaven

c. 1805; 223 × 295 mm. (British Museum, Department of Prints and Drawings)

The drawing is probably a suggestion for the design engraved by Schiavonetti as Plate 3 for Blair's *The Grave*, 1808, though in that different design all the vigour of the present sketch has been lost. The two figures on the left hold the Keys of Heaven.

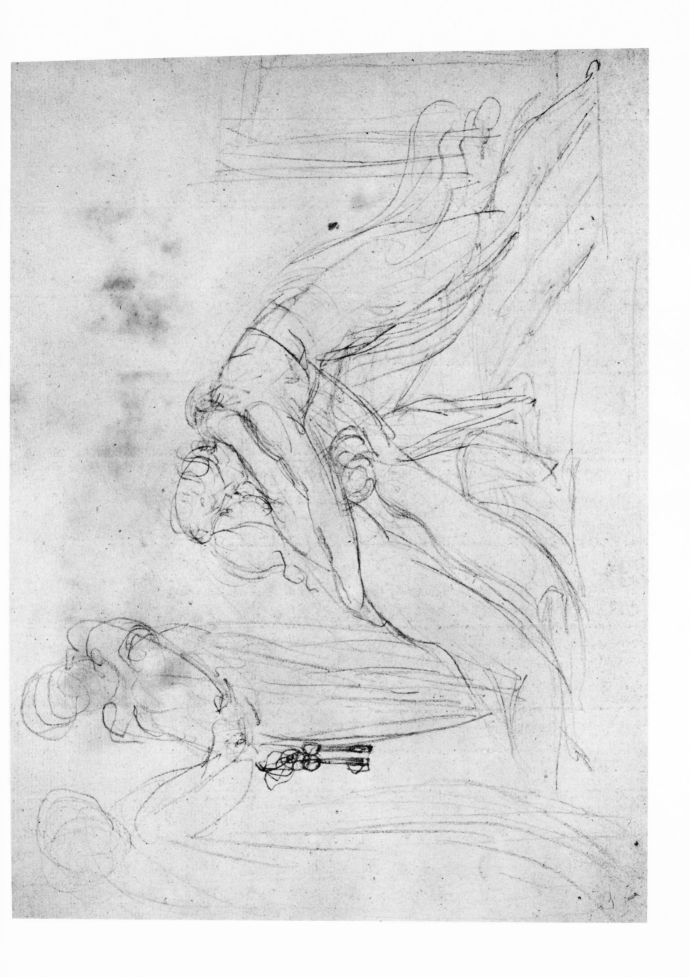

39 Death of the Strong Wicked Man

c. 1805; 140 × 270 mm. (Victoria and Albert Museum, London)

A powerfully scribbled sketch for part of the subject for the fourth plate engraved by Schiavonetti for Blair's *The Grave*, 1808. The dying man's wife crouches over him, and a mourner kneels at the head of his bed. In the finished design the mourner stands upright, and, in addition, the man's spirit is seen above, rushing in flames to his doom.

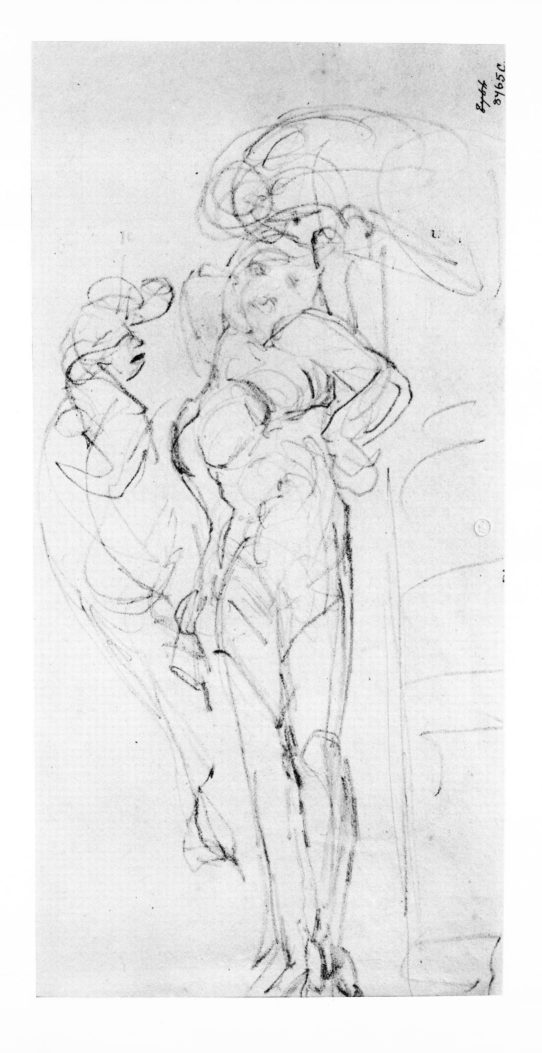

40 The Soul Hovering over the Body

c. 1805; 260 × 430 mm. (Tate Gallery, London)

A first idea for "The Soul hovering over the Body reluctantly parting with Life," engraved by Schiavonetti as Plate 5 for Blair's *The Grave*, 1808. In the engraved version the dying man, clothed in a long robe, is lying on his back, and the soul floats away from him in a graceful curve.

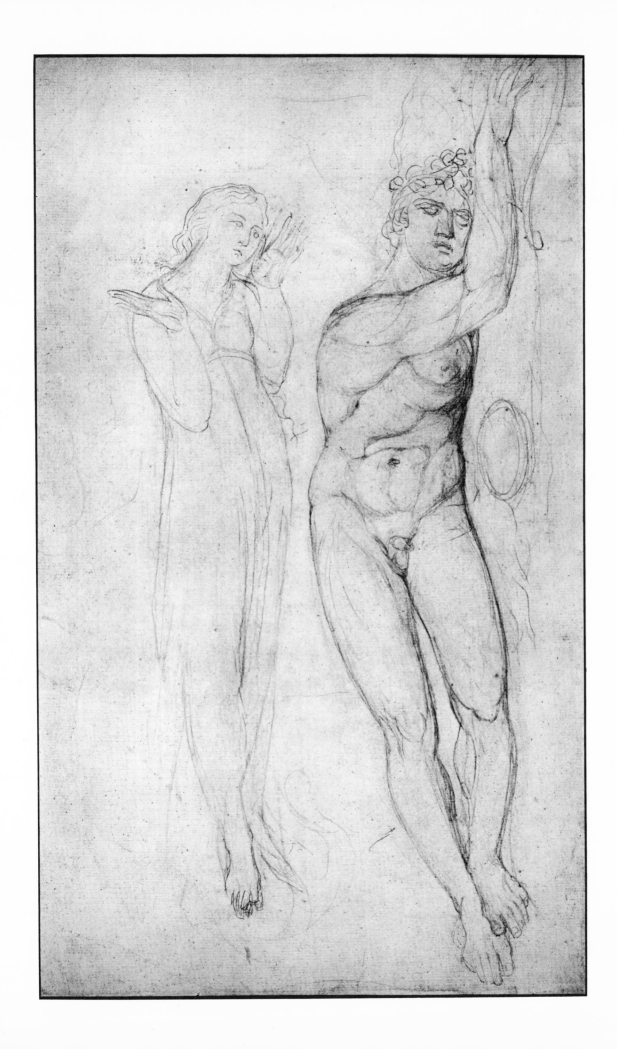

41 The Soul Exploring the Recesses of the Grave

c. 1805; 250 × 140 mm. (British Museum, Department of Prints and Drawings)

This rough sketch represents the first lines of Plate 7 of the illustrations engraved by Schiavonetti for Blair's *The Grave*, 1808. The living man stands apprehensively above, while his feminine soul, carrying a candle, enters a cavern and sees a corpse lying before her.

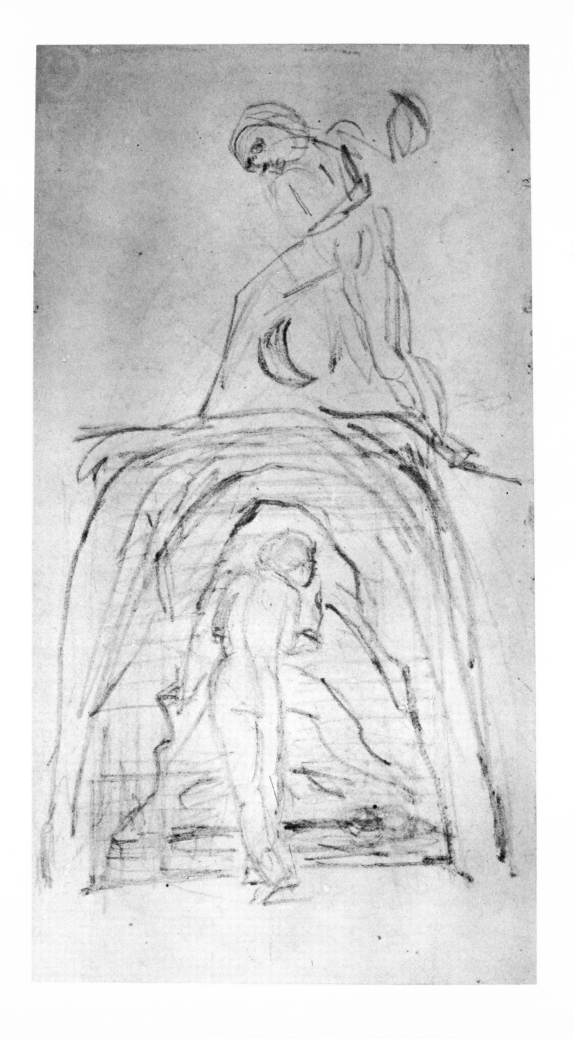

42 Satan, Sin and Death at the Gates of Hell

c. 1807; 253 × 202 mm. (John Work Garrett Library, Johns Hopkins University, Baltimore)

A study in pencil with some watercolour washes for the second design in the *Paradise Lost* series now in the Henry E. Huntington Library and Art Gallery, San Marino, California. Satan with dart and shield (left) faces Death with his spear (right). Between them Sin appears as described in *Paradise Lost*, Book ii, lines 648–59.

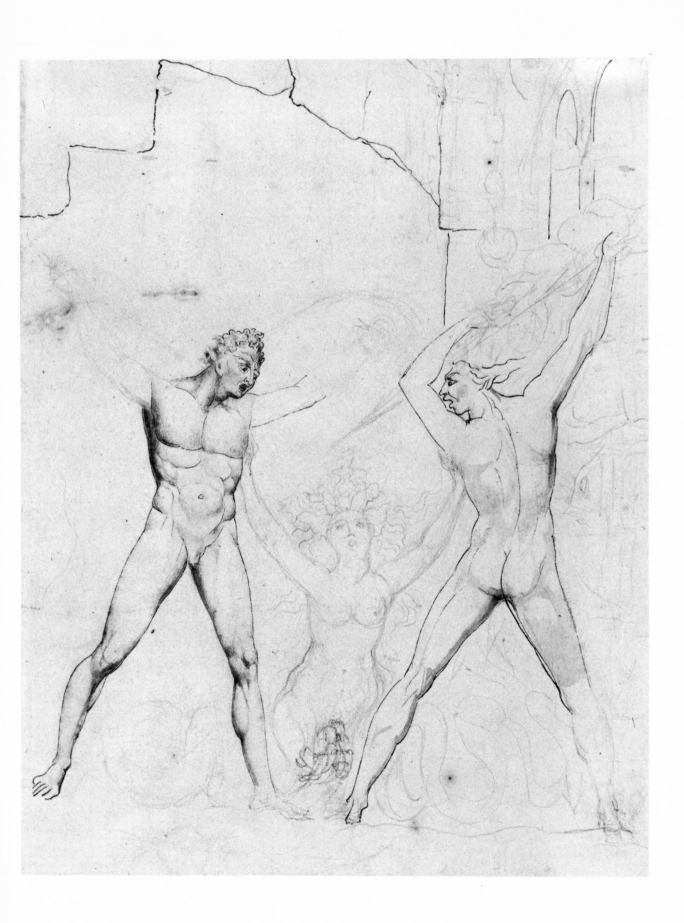

43 Adam and Eve in Paradise

c. 1807; 145 × 160 mm. (British Museum, Department of Prints and Drawings)

A pencil sketch for the central figures in the watercolour painting of "Satan Watches Adam and Eve," now in the Fogg Art Museum, Harvard University. Satan floats above them, watching their endearments.

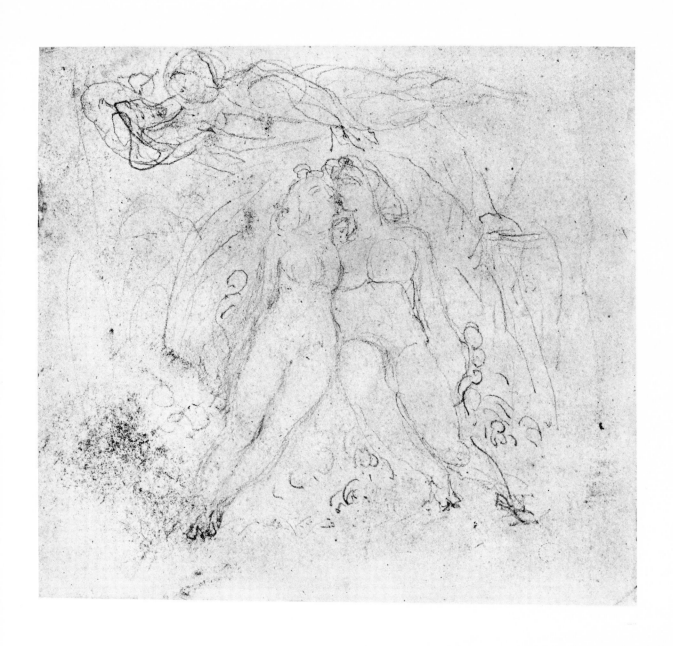

44 Eve Tempted by the Serpent

c. 1807; 230 × 126 mm. (Victoria and Albert Museum, London)

In this early study the Serpent seems to be kissing Eve's mouth rather than offering an apple, since the fruit is not seen. Blake used this figure, much modified, in both of the extant series of designs for *Paradise Lost* now in the Henry E. Huntington Library and Art Gallery, San Marino, California, and the Boston Museum of Fine Arts.

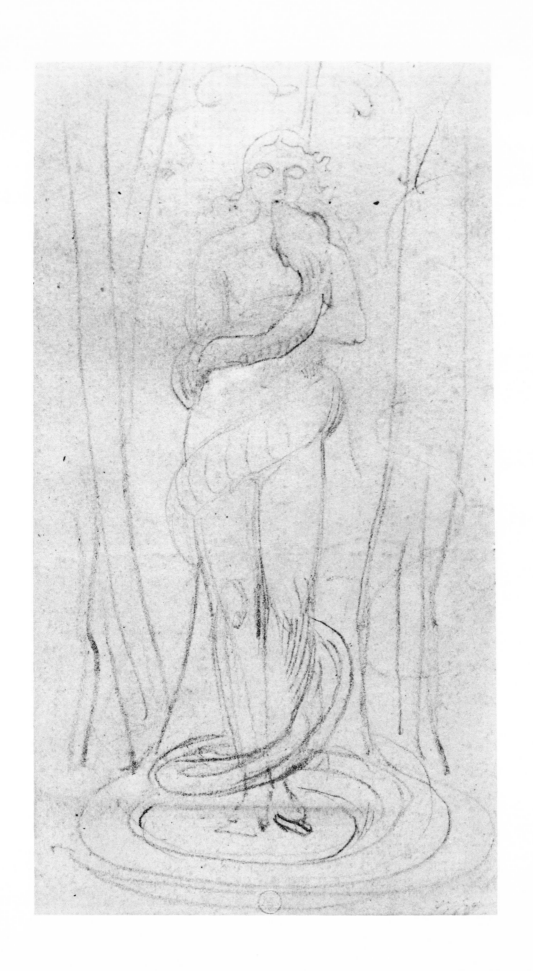

45 Adam and Eve leaving Paradise

c. 1807; 111 × 162 mm. (Mrs Francesca Wiig, Worthington, Mass.)

Adam and Eve look back with their arms raised in a farewell to a group of angelic figures. On the left Satan is calling up his legions with a background of flames. This composition was not used in any of Blake's watercolour designs for *Paradise Lost*.

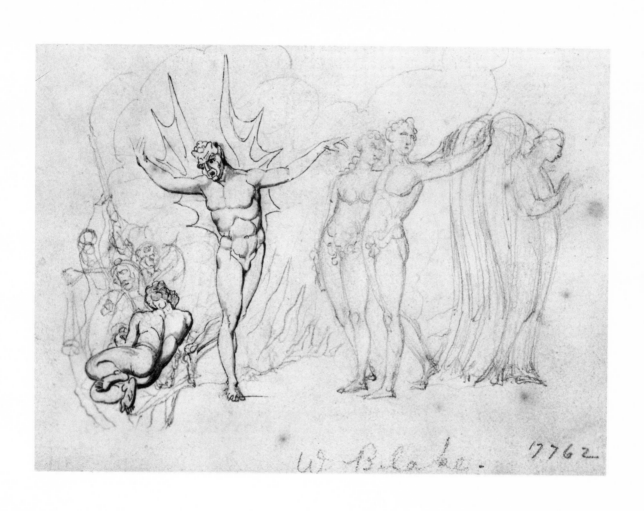

W Blake. 1762

46 The Spiritual Form of Nelson Guiding Leviathan

c. 1808; 290 × 265 mm. (British Museum, Department of Prints and Drawings)

A sketch for the tempera painting exhibited by Blake in 1809 and now in the Tate Gallery, London. This and the companion picture of "The Spiritual Form of Pitt Guiding Behemoth" are to be regarded as "apocalyptic visions of war" (Sir Anthony Blunt).

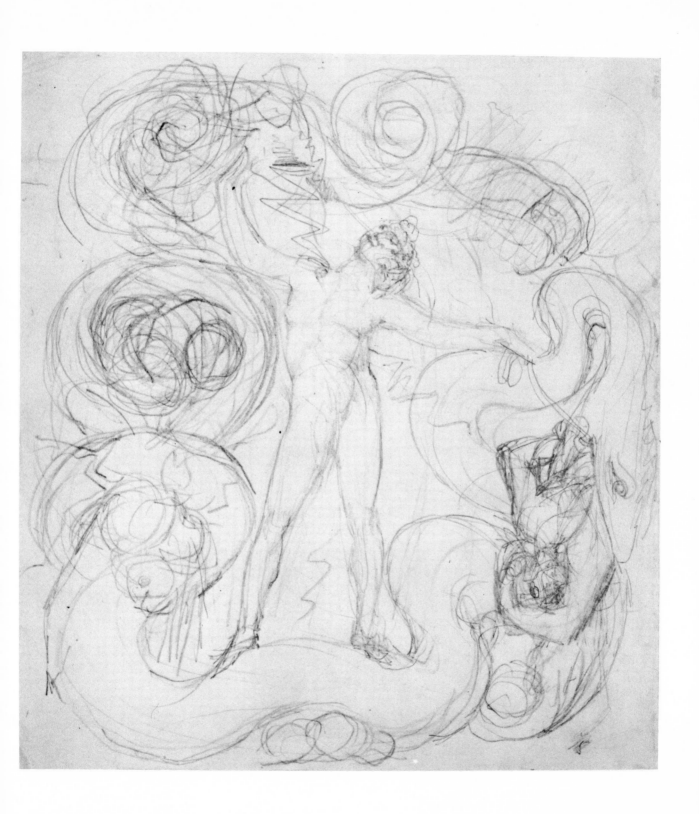

47 Cain and the Body of Abel

c. 1808; 175 × 240 mm. (British Museum, Department of Prints and Drawings)

A pencil study for part of the tempera painting of "The Body of Abel found by Adam and Eve," now in the Tate Gallery, London. The sketch shows only Cain, the murderer, with Abel's body dimly indicated beside the grave. The huge orb of the sun hangs in the background. Adam and Eve mourning over Abel's body are not shown. The drawing was probably made for an earlier version of the picture exhibited by Blake in 1809. It is inscribed by Tatham: "First thoughts of Cain. F. T." Also initialled by John Defett Francis, a former owner of the drawing.

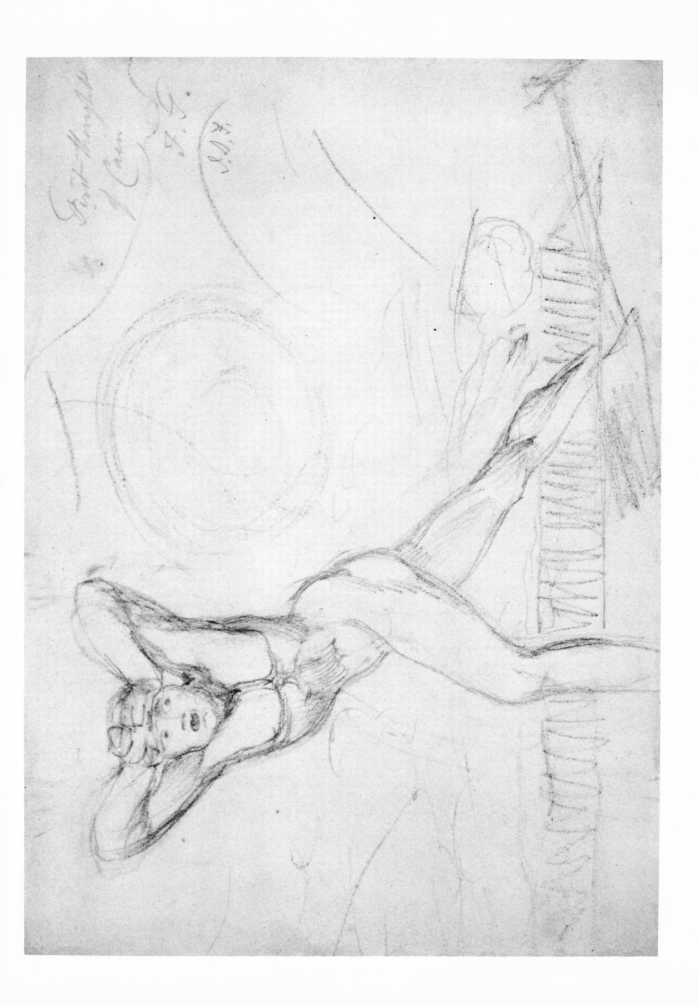

48 The Bard, from Gray's Poems

1809; 630 × 450 mm. (Philadelphia Museum of Art)

This large pencil sketch is a study for the tempera painting in the Tate
Gallery, London, dated 1809. It illustrates Gray's ode, "The Bard,"
showing the poet with his harp standing on a rock; below him King
Edward I and Queen Eleanor crouch in a confused heap. Floating above
him are the spirits of other Bards killed by the King. Gray's ode is founded
on a tradition that King Edward, when he conquered Wales in 1284,
ordered all the Bards, or poets, to be put to death. There is another
inferior version of the subject on the other side of the sheet.

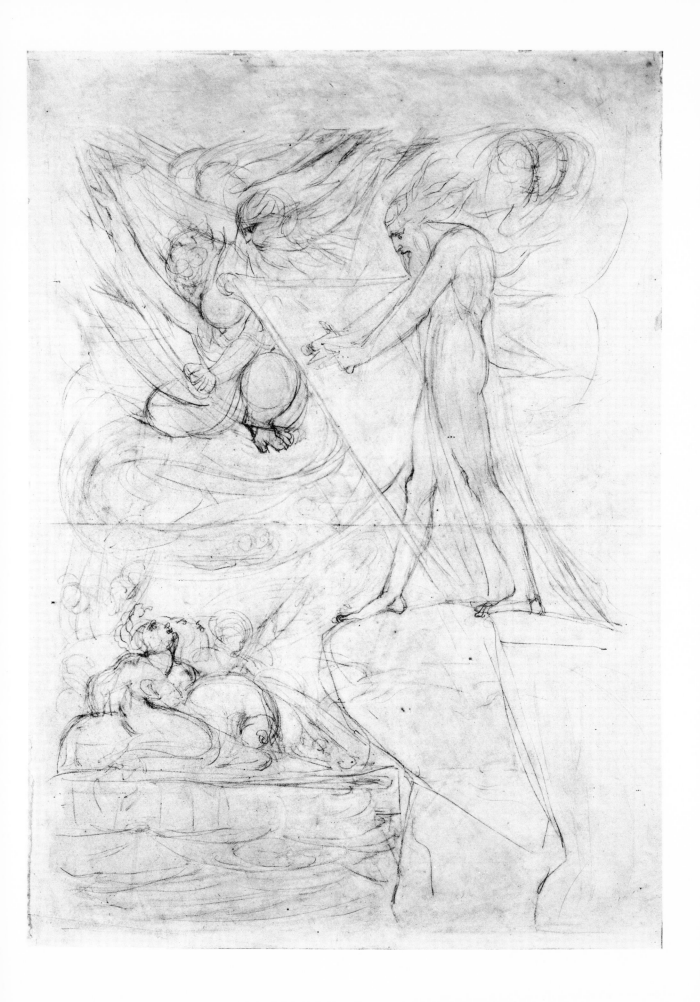

49 The Descent of Peace

1809; 240 × 185 mm. (National Gallery of Art, Washington, D.C.,
Lessing J. Rosenwald Collection)

A pencil sketch for the first of six watercolour designs for Milton's ode
"On the Morning of Christ's Nativity." One set of these is in the Henry E.
Huntington Library and Gallery, San Marino, California; another is in the
Whitworth Art Gallery, Manchester, England. In this design the Angel
descends headlong over the stable where Mary kneels swooning into
Joseph's arms. The infant Christ springs from her body, while Elizabeth
with the boy, St John, kneels before her. Below is the recumbent figure of
Nature looking up at the scene of the Nativity. The drawing resembles the
watercolour in the first set more than it does the second. Inscribed:
"sketched by/William Blake/vouched/by Fred.ᵏ Tatham."

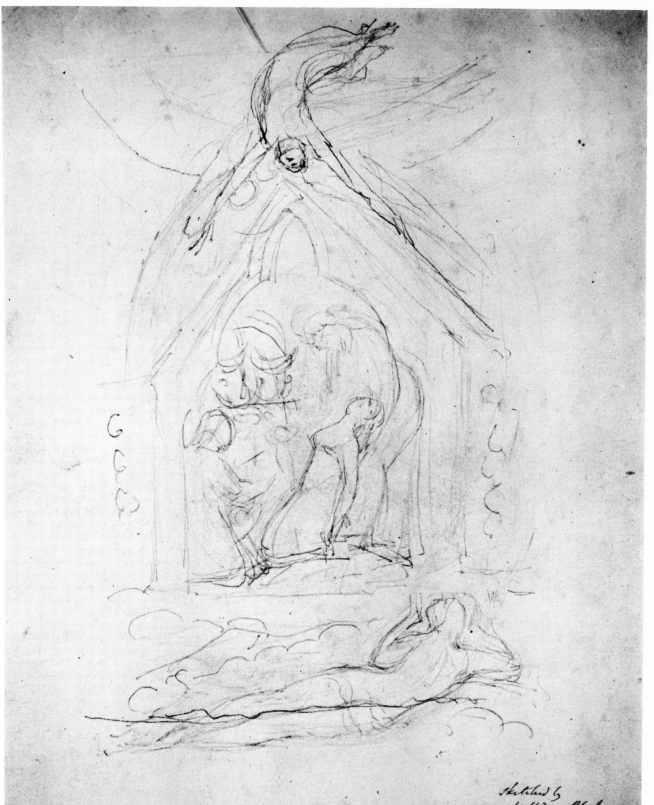

Sketched by
William Blake
vouched
by Mrs. Tatham

50 Male Figure Kneeling

c. 1810; 246 × 311 mm. (Yale University Art Gallery)

This unidentified subject could perhaps represent Los, the Sun God and
Spirit of Poetry, with a dart in his left hand and a sickle (or
thunderbolt?) in his right.

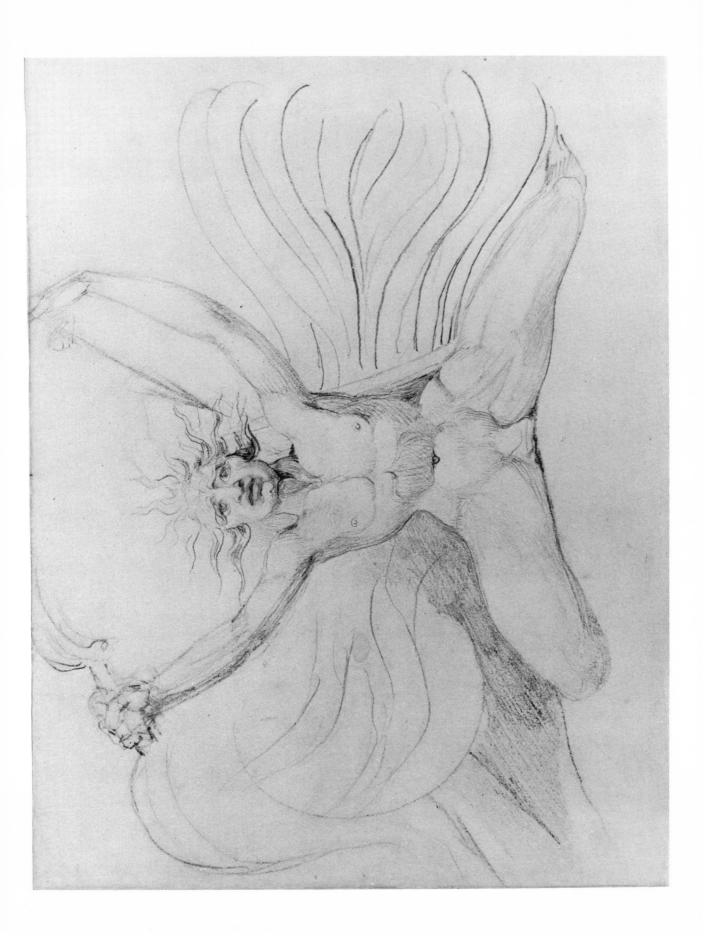

51 A Vision of the Last Judgment

c. 1810; 452 × 345 mm. (National Gallery of Art, Washington, D.C., Lessing J. Rosenwald Collection)

A large pencil drawing worked over with ink and with a few touches of watercolour added. Christ sits in judgment above. Below is a cavern wherein is seated the Great Red Dragon with seven heads. Around them swirl hundreds of figures identifiable by reference to Blake's description of a painting now lost (*Complete Writings*, ed. Keynes, 1966, pp. 604–17). There are other versions in pencil and watercolour.

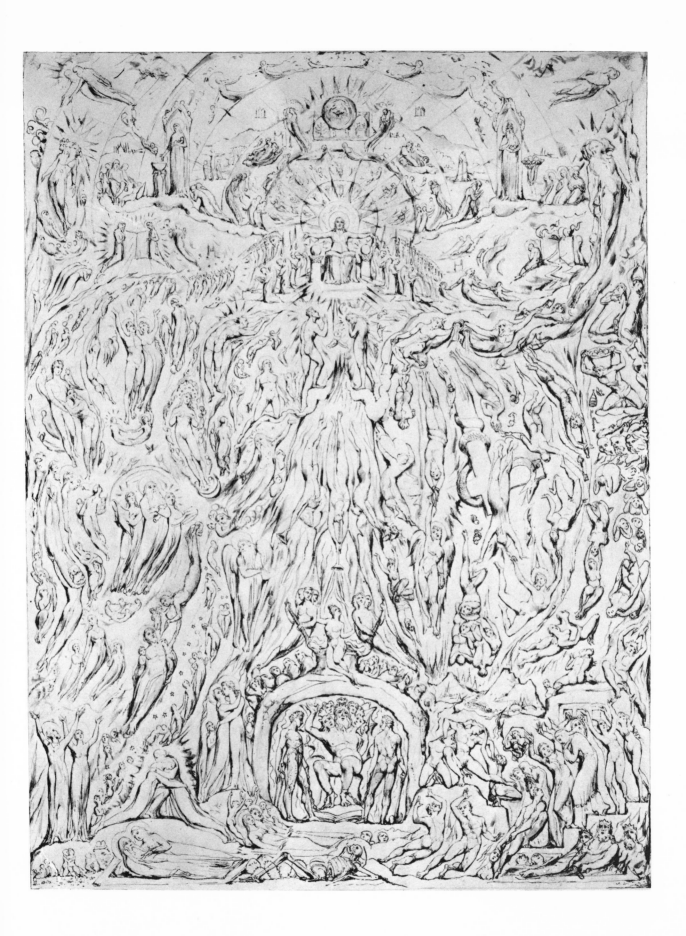

52 A Warring Angel

c. 1810; 319 × 444 mm. (National Gallery of Art, Washington, D.C., Lessing J. Rosenwald Collection)

A nude figure with wings is striding with raised arm to his left; he holds a sword in his right hand. Not further identified, but probably a Miltonic subject.

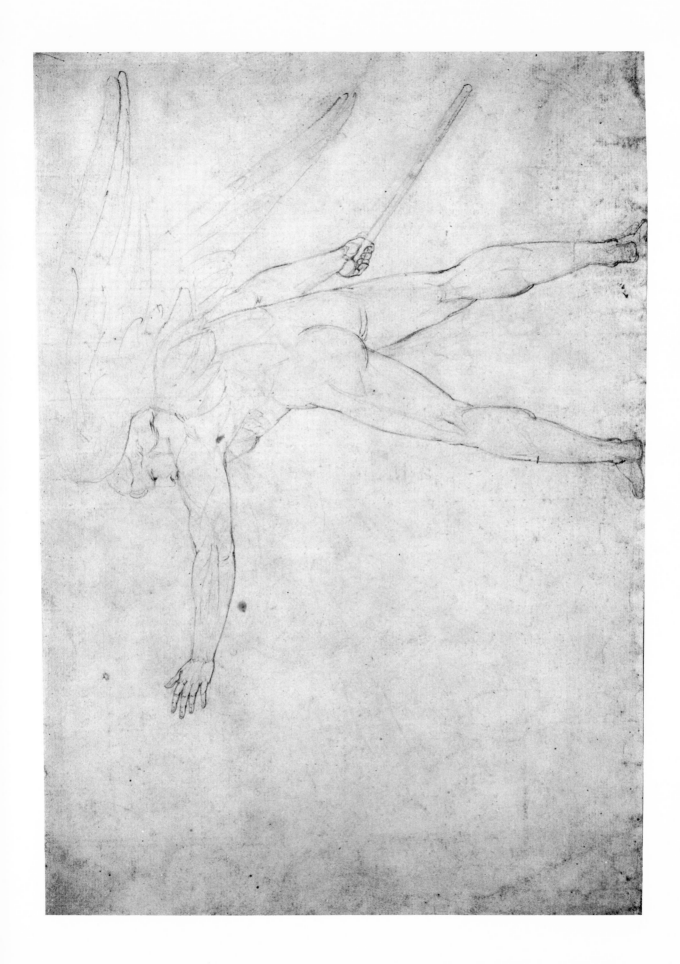

53 Time's Triple Bow

c. 1815; 318 × 240 mm. (National Gallery of Art, Washington, D.C., Lessing J. Rosenwald Collection)

A quickly scribbled, though powerful, sketch of Time for Plate 35 of *Jerusalem*. The horse carrying Time in the finished design is barely indicated in the sketch.

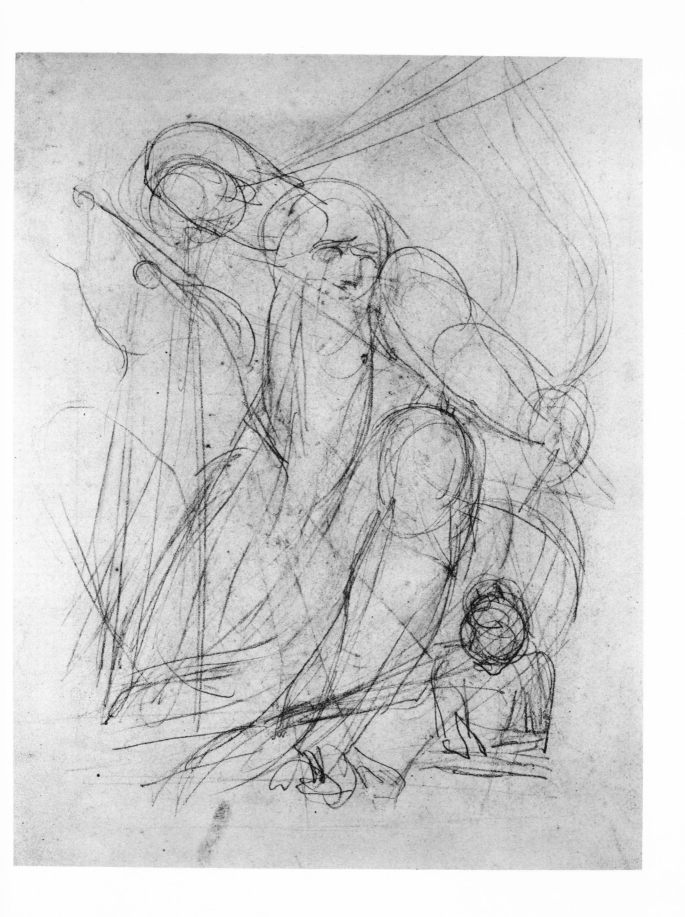

54 Hand and Jerusalem

c. 1815; 170 × 230 mm. (British Museum, Department of Prints and Drawings)

A pencil study for Plate 26 of *Jerusalem*, on which the names of the two figures are inscribed below their feet. Hand, one of the sons of Albion in Blake's mythology, symbolizes man's ruthless power of reasoning, the source, in Blake's mind, of the materialism of the industrial revolution and of war. In the drawing, Hand, enveloped in flames, is followed by the form of Jerusalem, or Liberty, dreading what she sees before her.

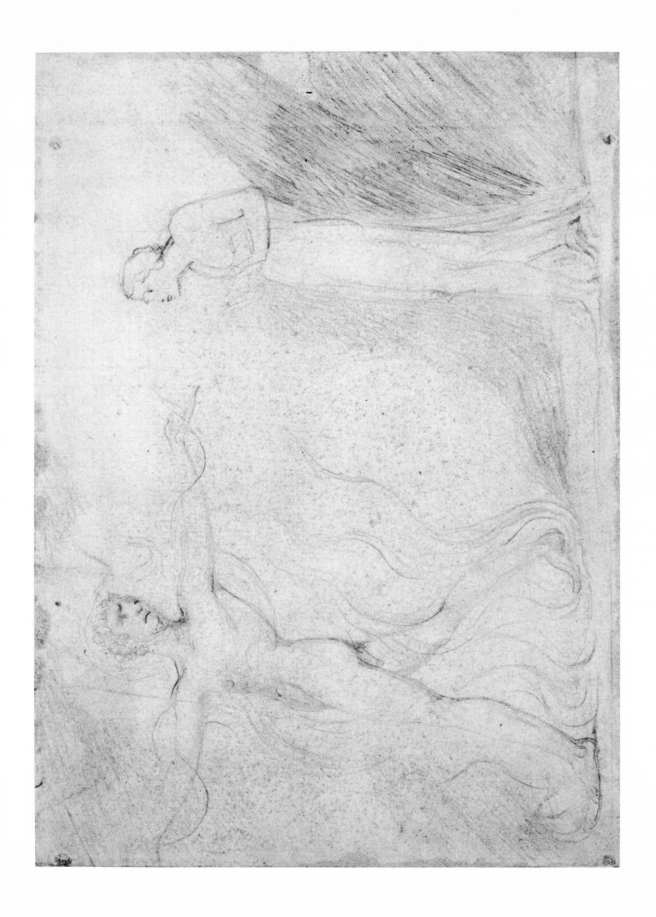

55 Humanity Asleep

c. 1815; 170 × 235 mm. (National Gallery of Art, Washington, D.C., Lessing J. Rosenwald Collection)

A careful pencil drawing for Plate 37 of *Jerusalem*. Humanity, represented by Blake's Albion, sits on a rock with his head sunk on a scroll lying across his knees. The scroll, representing the Book of the Mosaic Law, carries the prohibitions resulting from the Spectre, or reasoning power, of fallen Man. In the etched plate the rock on Albion's right is inscribed in reversed writing:

> Each Man is in his Spectre's power
> Until the arrival of that hour
> When his Humanity awake
> And cast his Spectre into the Lake.

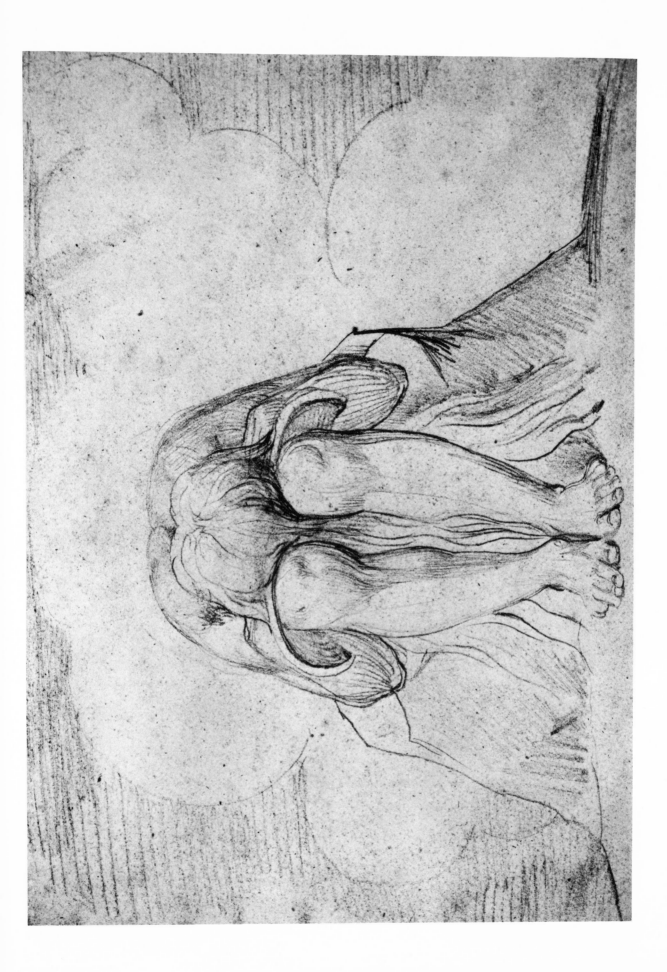

56 The Journey of Life

c. 1815; 240 × 210 mm. (British Museum, Department of Prints and Drawings)

A pencil study for Plate 97 of *Jerusalem*, Blake's last illuminated book. In the book the design is reversed and the traveller carries a globe of light in his left hand instead of the staff. A similar figure had been used in a watercolour design for Young's *Night Thoughts* painted about 1796. In all of these forms the idea is the same, that is, the poet's course through life as expressed by Blake in 1802 in a letter to his friend Butts: "I have Conquer'd and shall still Go on Conquering. Nothing can withstand the fury of my Course among the Stars of God & in the Abysses of the Accuser." The title is scrawled at the top of the sheet.

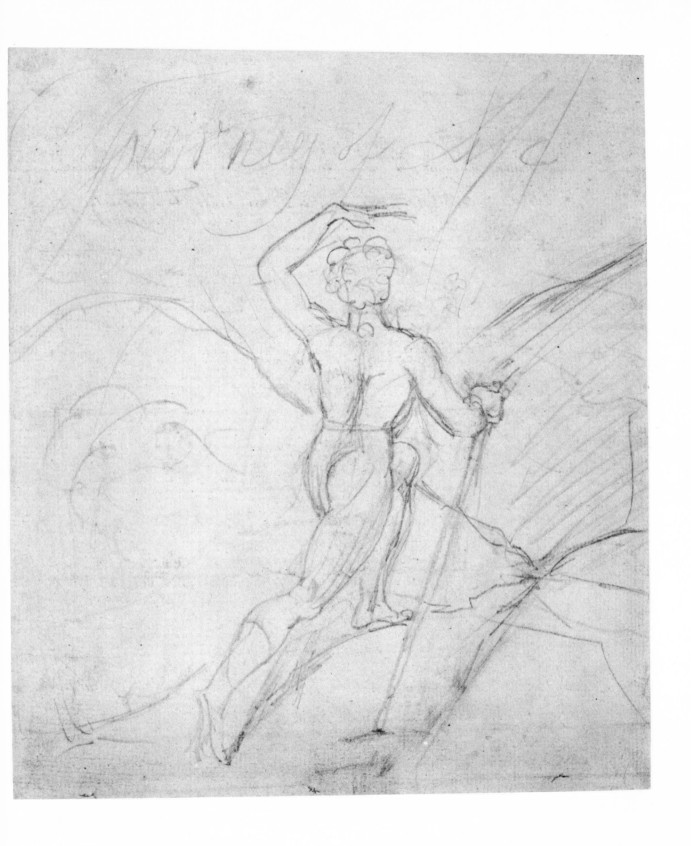

57 Los Supporting the Sun

c. 1815; 178 × 127 mm. (National Gallery of Art, Washington, D.C., Lessing J. Rosenwald Collection)

The youthful figure of Los, the Spirit of Poetry, stands with his legs apart, supporting the orb of the sun above his head. The earth's orb is indicated below. Flames and thunderbolts stream on either side. The subject was not used elsewhere.

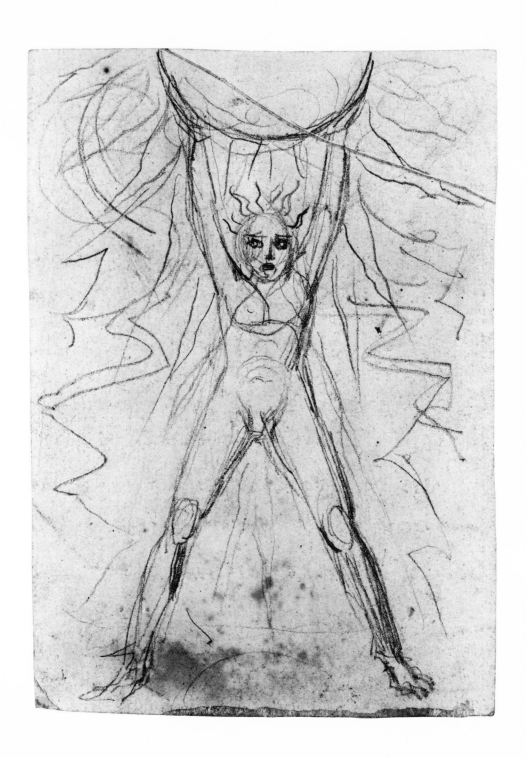

58 Laocoön: the Antique Group

c. 1815; 320 × 228 mm. (Henry J. Crocker, U.S.A.)

This pencil drawing is an example of Blake's skill in drawing from a cast and may be contrasted in feeling with his imaginative version of the same group (Plate 59). He made the drawing about 1815 in the Royal Academy rooms at Somerset House for an engraving commissioned as an illustration in Rees's *Cyclopaedia*, published in 1820. About 1818 he used it again for a large private plate, giving the figures symbolic meanings and adding around them aphorisms on art and religion wherever he could find room. Frederick Tatham inscribed some facts about the present drawing at the bottom of the sheet.

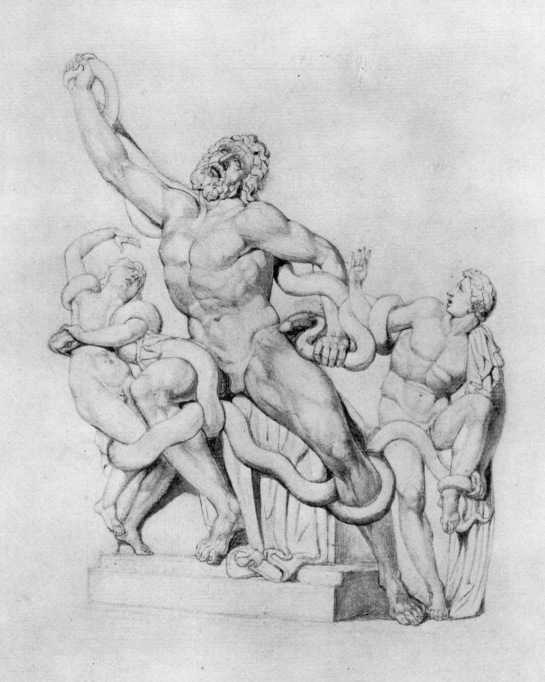

This drawing was made by Mr Blake in the Royal
Academy Somerset House for a small plate he made of the
Laocoon for the Article in the Encyclopedia. the Article itself is
on Sculpture being written by Flaxman. when Mr B was drawing
this his old friend Fuseli came in & said to Mr B take you a hat if you

59 Laocoön: Blake's Version

c. 1818; 533 × 438 mm. (Sir Geoffrey Keynes Collection)

A large drawing chiefly in pencil with the left foot of the central figure worked up by pen and the face coloured with pink wash. Not taken any further as far as is known. In about 1815 Blake had made a drawing of the Laocoön group (Plate 58) for an encyclopaedia. Probably somewhat later Blake drew this unconventional version; the priest, now clothed in a long robe, has taken on the character of Urizen-Jehovah; his two sons, Satan and Adam, are struggling with the serpents. The drawing is inscribed "The Laocoön," but not in Blake's hand.

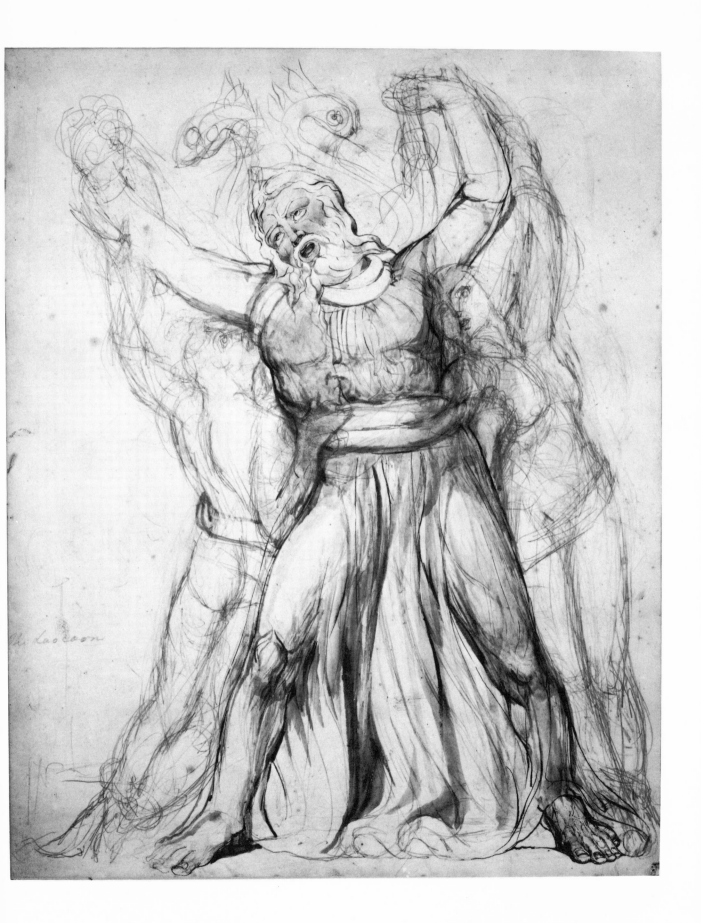

60 Portrait of John Varley

c. 1819; 280 × 192 mm. (National Portrait Gallery, London)

John Varley, landscape painter and astrologer (1778–1842), was a friend of Blake in his later years and encouraged him to draw many of his "visionary heads" in 1819–20. Inscribed: "Portrait of J. Varley/By W^m Blake" and "J. Varley Born/August 17. 1778/18.56 pm ♇ ascending."

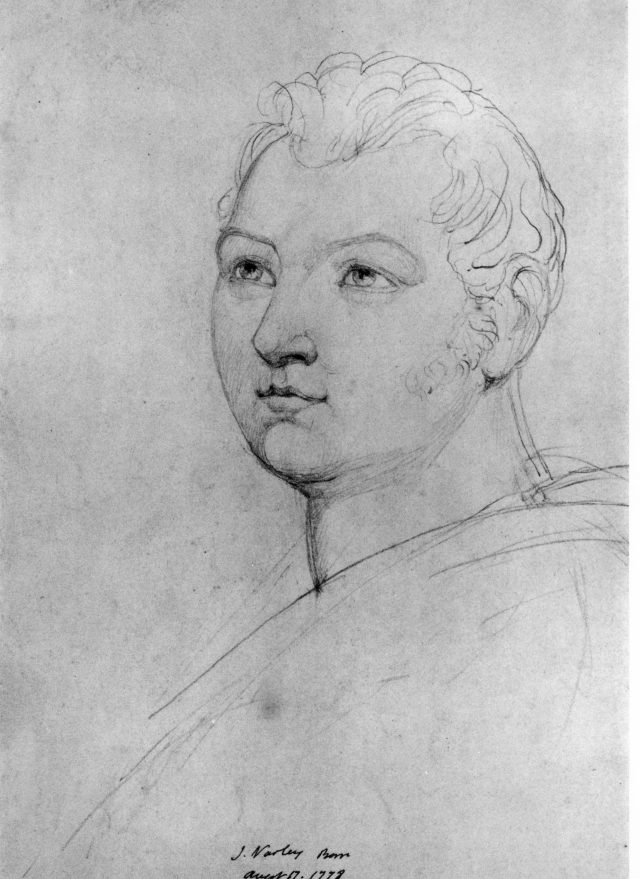

J. Varley Born
august 17. 1778
18.56 ♉ ascending

Portrait of J Varley
By Wm Blake.

61 A Visionary Head, unidentified

c. 1819; 205 × 157 mm. (M. D. E. Clayton-Stamm Collection, England)

The historical character represented by this drawing from the Blake–Varley sketchbook has not been identified with certainty, but it may well be a vision of a prince of the royal household. The coat of arms on his shoulder bears the three lions of England.

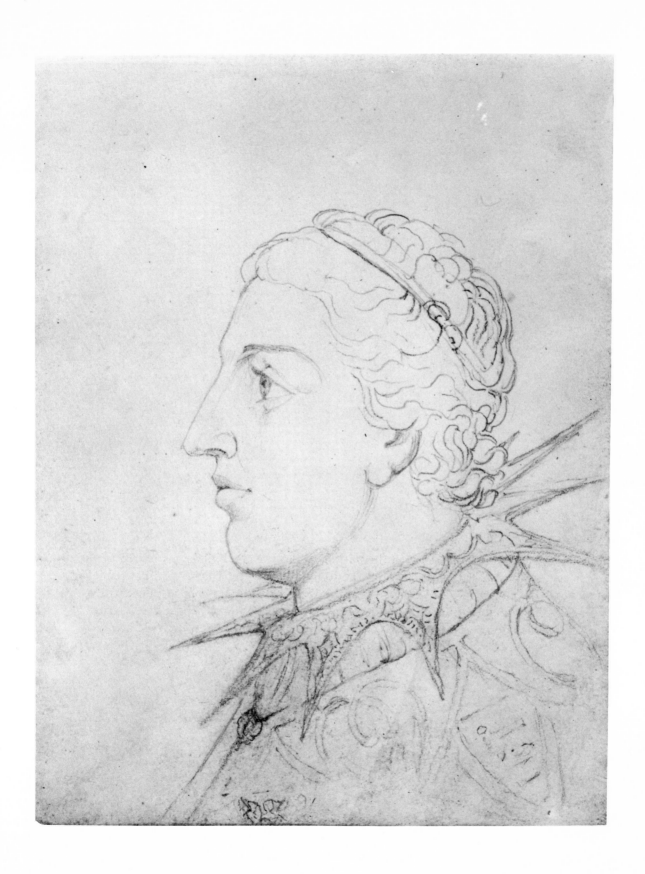

62 The Man Who Built the Pyramids

1819; 300 × 215 mm. (Tate Gallery, London)

Blake has projected into this visionary head of the builder his hatred of the mathematical materialism of the Egyptians and their architecture. A small drawing alongside shows his thick lips parted; the drawing in the centre is presumably the mason's workshop. At the bottom is a book with hieroglyphics on the cover. It is inscribed by Varley with the title below and is dated "Oct. 18. 1819."

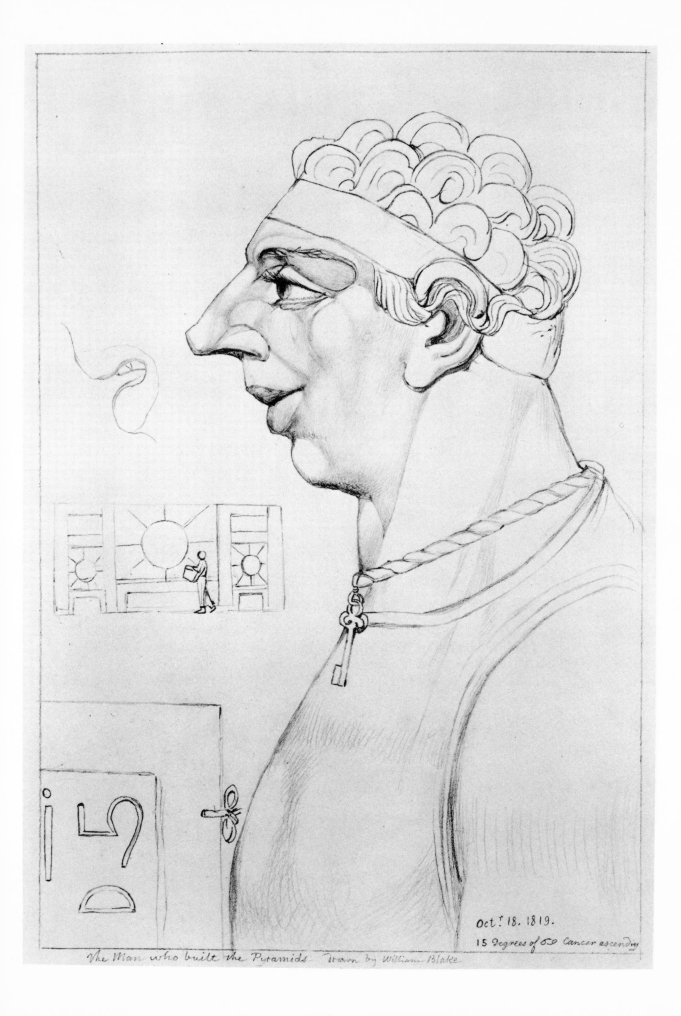

Oct.ʳ 18. 1819.

15 Degrees of ♋ Cancer ascending

The Man who built the Pyramids drawn by William Blake

63 Blake's Instructor

c. 1819; 295 × 235 mm. (Tate Gallery, London)

The drawing is inscribed below, probably by Varley: "Imagination of a man who Mr Blake has rec.ᵈ instruction in Painting &c from." Two other versions of the same subject are known; one, also in the Tate Gallery, is inscribed: "The Portrait of a Man who instructed Mʳ Blake in Painting &c in his Dreams."

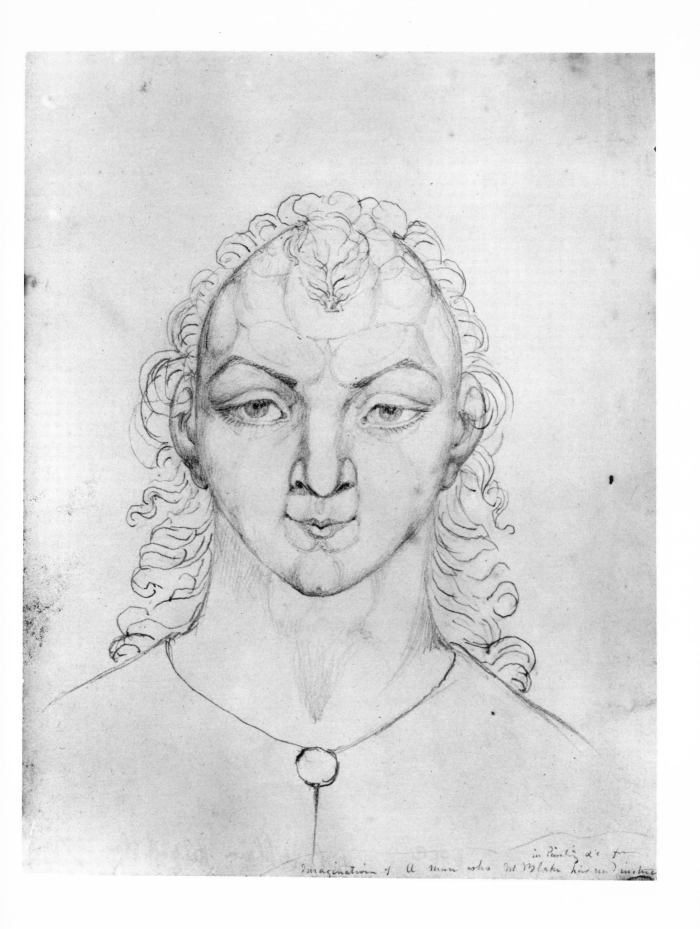

Imagination of A man who Mr Blake has recd instruct in Painting &c from

64 Visionary Head of Caractacus

c. 1819; 195 × 150 mm. (Sir Geoffrey Keynes Collection)

An impressive drawing of the heroic leader of the Britons against the generals of the Roman Emperor Claudius. Drawn for John Varley and originally part of the recently rediscovered Blake–Varley sketchbook. There is a rough landscape drawing by Varley on the other side of the sheet.

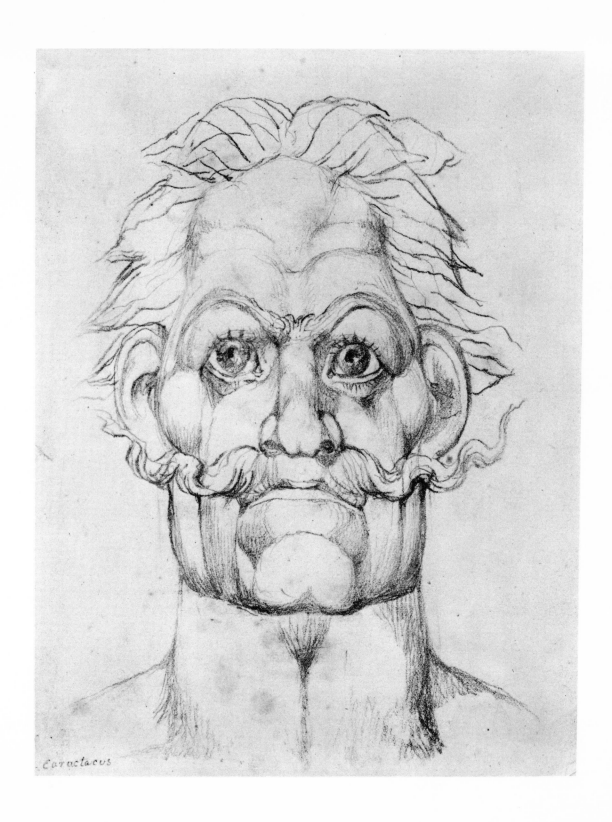

Caractacus

65 Visionary Head of Voltaire

c. 1820; 230 × 152 mm. (Dr John Lipscomb, Canterbury, England)

The drawing is inscribed, probably by John Varley: "The spirit of Voltaire by Blake."

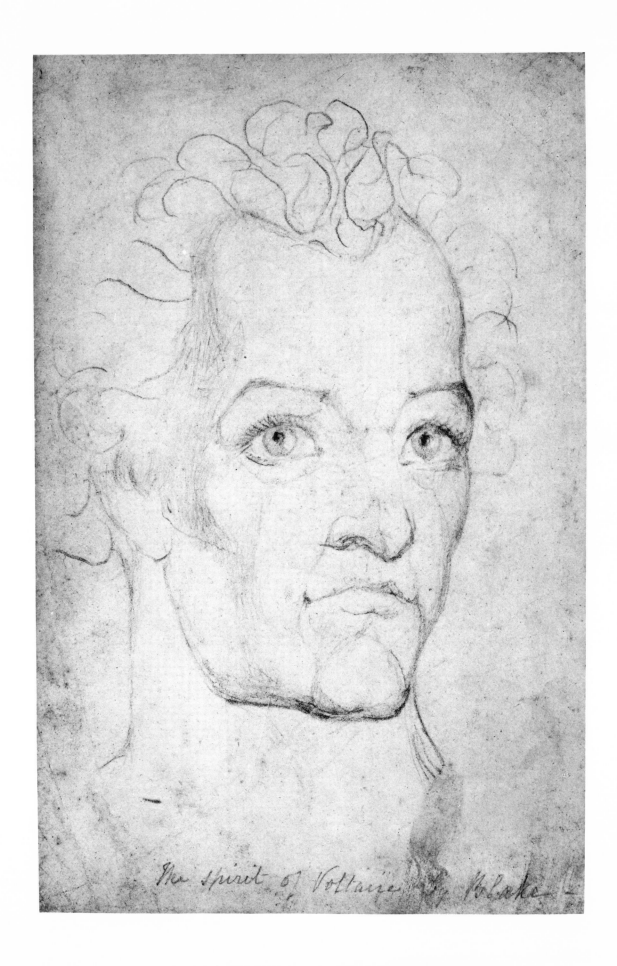

The spirit of Voltaire By Blake

66 Visionary Head of Friar Bacon, and the Poet Gray

c. 1820; 197 × 162 mm. (Pembroke College, Cambridge, England)

Roger Bacon, the thirteenth-century philosopher, on the right is a true
visionary head, whereas the profile of Gray on the left is clearly
remembered from a portrait, probably the posthumous drawing by the Rev.
William Mason.

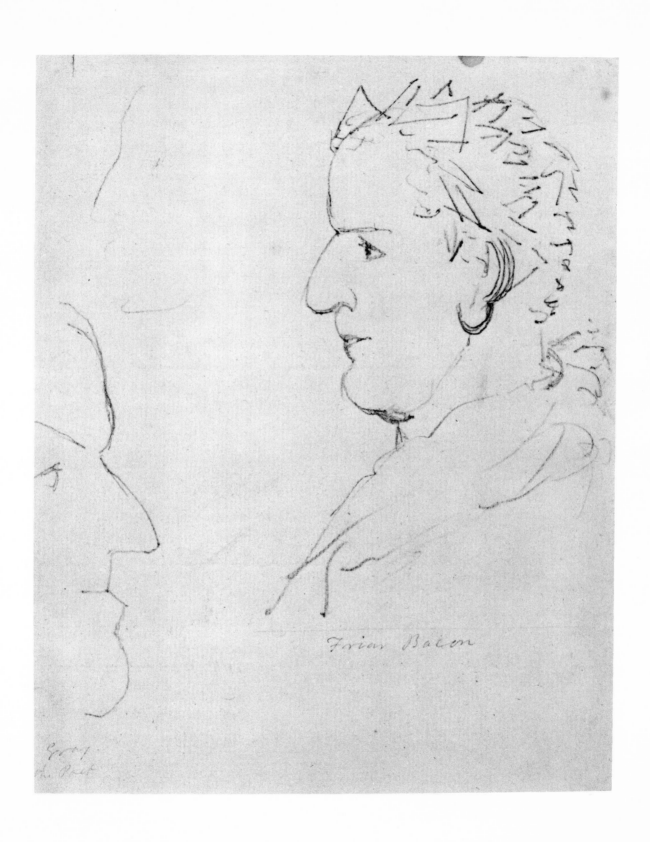

Friar Bacon

Gray
the Poet

67 Visionary Heads of Uriah and Bathsheba

c. 1820; 205 × 330 mm. (Henry E. Huntington Library and Art Gallery, San Marino, Cal.)

The two heads, drawn for Varley and Linnell, are inscribed below "uriah the Husband of Bathsheba" and "Bathseba."

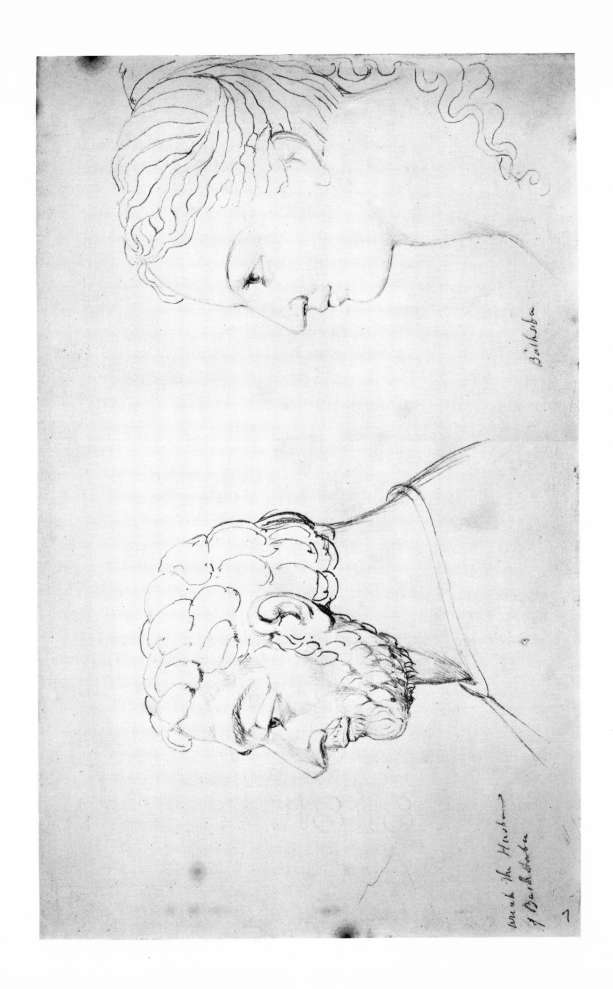

Bathsheba

weak the Herd
of Bathsheba

7

68 Visionary Head of Queen Eleanor, Wife of King Edward I

c. 1820; 195 × 155 mm. (Henry E. Huntington Library and Art Gallery, San Marino, Cal.)

This majestic head bears considerable resemblance to the pencil drawing (Plate 1) made by Blake in 1774 from the Queen's monument in Westminster Abbey, when working as an apprentice for James Basire. Blake, while working for Varley, had certainly remembered his drawing of forty years before.

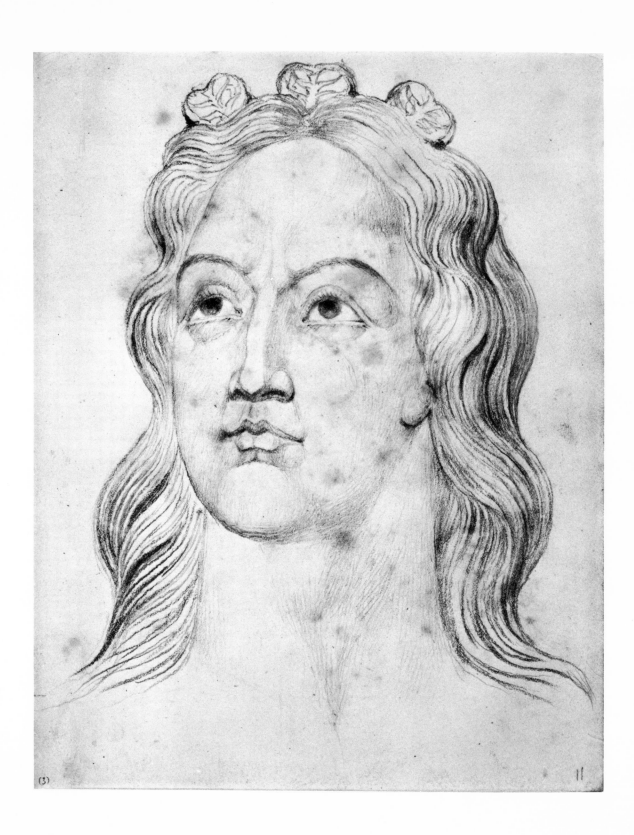

69 Visionary Heads of Saladin and the Assassin

c. 1820; 223 × 140 mm. (Henry E. Huntington Library and Art Gallery, San Marino, Cal.)

Two visionary heads drawn for John Varley. Below is a head of Saladin, Sultan of Egypt during the third Crusade in the twelfth century. Inscribed by Varley: "Saladin Blake fecit." Above is a man lying on his back inscribed: "The Assassin laying dead at the feet of Ed.^wd 1^st in the holy land." The assassin was a messenger from the Emir of Jaffa, who attempted to kill King Edward I during his crusade in 1272.

The Assassin laying dead at the feet of Ed^{ws} I^{st} in the holyland

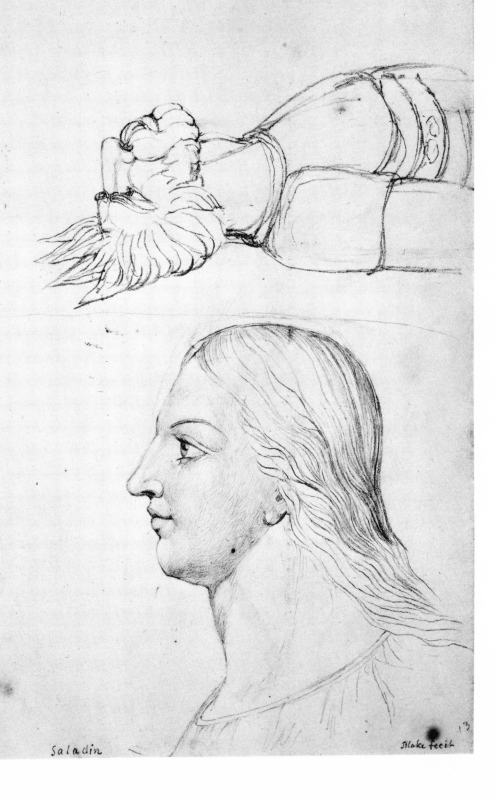

Saladin Blake fecit

70 Visionary Heads of Joseph and Mary and the Room
They Were Seen in

c. 1820; 200 × 315 mm. (Henry E. Huntington Library and Art
Gallery, San Marino, Cal.)

The youthful pair are carefully drawn with their heads inclined towards
one another. Mary has her hands crossed on her breast. Between the two
figures is a small drawing of "the room they were seen in" (that is, in
Blake's vision) containing Joseph and Mary as full-length figures with a
bed in the background. Behind Joseph is a tall bearded figure, presumably
his father. The title is written on the other side of the sheet by Varley or
Linnell.

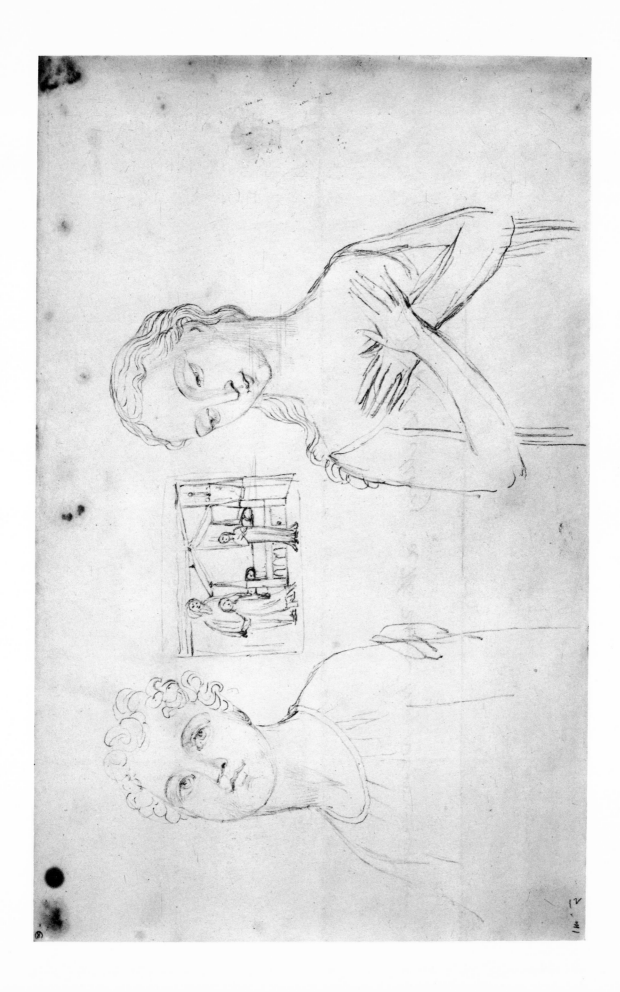

71 Head of Cancer

c. 1820; 165 × 114 mm. (Mr Leonard Baskin, Smith College, Northampton, Mass.)

The drawing is inscribed "Cancer" by the astrologer, John Varley, but Blake may have intended it as a self-caricature. Varley included a very different version among the engravings in his *Zodiacal Physiognomy*, London, 1828.

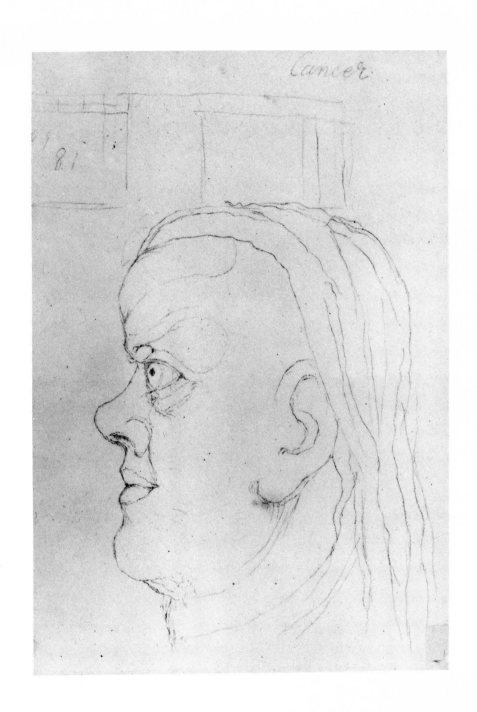

72 Visionary Head of Corinna the Theban

c. 1820; 260 × 415 mm. (University of Kansas Museum of Art, Lawrence, Kansas)

The poetess is shown both full face and in profile. Probably drawn for John Varley.

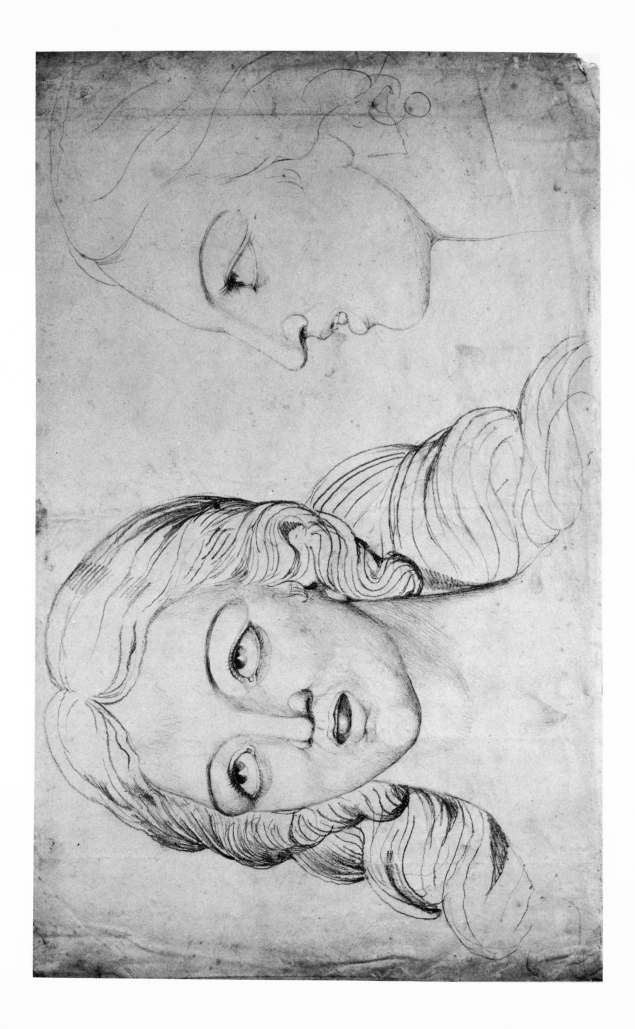

73 Old Parr When Young

1820; 300 × 185 mm. (The Henry E. Huntington Library and Art Gallery, San Marino, Cal.)

This careful drawing of a thickset youngish man was drawn for John Varley, who inscribed it ''old Parr when young, Viz 40'' and ''Aug 1820/W. Blake fecit.'' Thomas Parr was an aged countryman reputed to be 153 years old. He was taken to London by Lord Arundel in 1635 to be shown to King Charles I, but died while there. A postmortem was performed by Dr William Harvey, who found all his organs healthy. The drawing was evidently used as the basis of design no. 28, ''The Symbolic Figure of the Course of Human History Described by Virgil,'' for Dante's *Divine Comedy*.

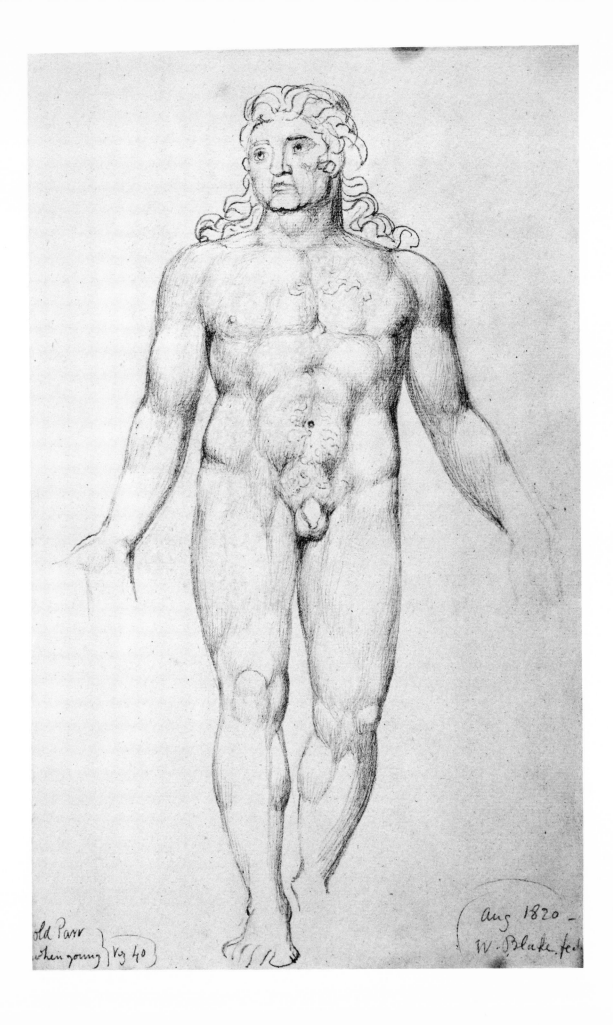

Old Parr
when young Vg 40

Aug 1820 —
W. Blake fecit

74 Head of Job

c. 1823; 260 × 200 mm. (Sir Geoffrey Keynes Collection)

This very careful drawing was certainly made in connexion with Blake's
Illustrations of the Book of Job. It most resembles Job's aspect in no. 14 of
the series, where Job is looking up to Heaven and the Sons of God shouting
for joy.

75 Satan with a Sword

c. 1823; 216 × 122 mm. (Sir Geoffrey Keynes Collection)

A rough sketch of a nude man, seen from behind, carrying a sword in his right hand. The figure resembles the one engraved in miniature at the top of no. 4 of the plates for *Illustrations of the Book of Job*, 1826. This, in reverse, has no sword, but represents Satan, being inscribed: "Going to & fro in the Earth & walking up & down in it" (*The Book of Job*, i, **7**). It is drawn on part of a proof-sheet of Hayley's *Ballads*, 1802, three printed letters remaining at the edge, and is inscribed below: "Drawing by William/Blake./vouched by/Fredᵏ Tatham."

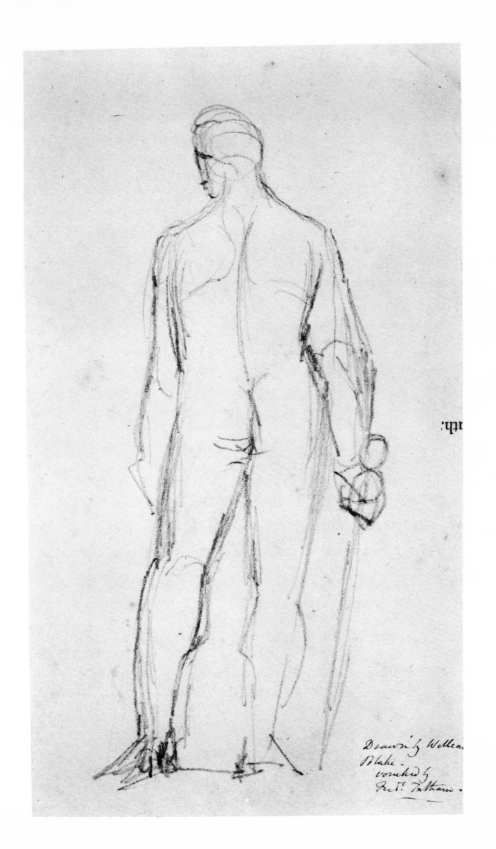

Drawing William
Blake.
vouched by
Fredk. Tatham.

76 Job's Sons and Daughters Overwhelmed by Satan

c. 1823; 200 × 135 mm. (Fitzwilliam Museum, Cambridge, England)

A pencil study for no. 3 of the engravings for *Illustrations of the Book of Job*, 1826, with indications of the border design.

3

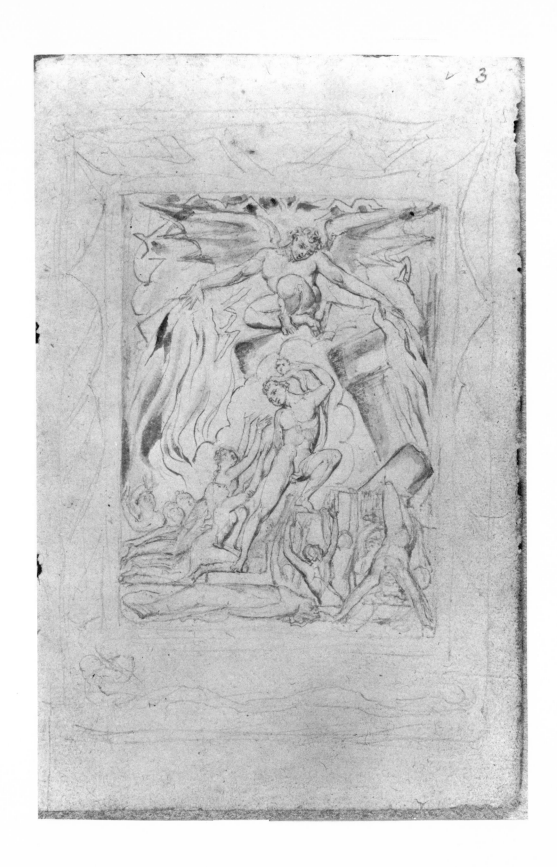

77 Satan Smiting Job with Boils

c. 1823; 200 × 135 mm. (Fitzwilliam Museum, Cambridge, England)

A pencil study for no. 6 of the engravings for *Illustrations of the Book of Job*, 1826, without the border design. It differs in detail from the two earlier watercolour drawings of the subject and from the tempera painting in the Tate Gallery, London.

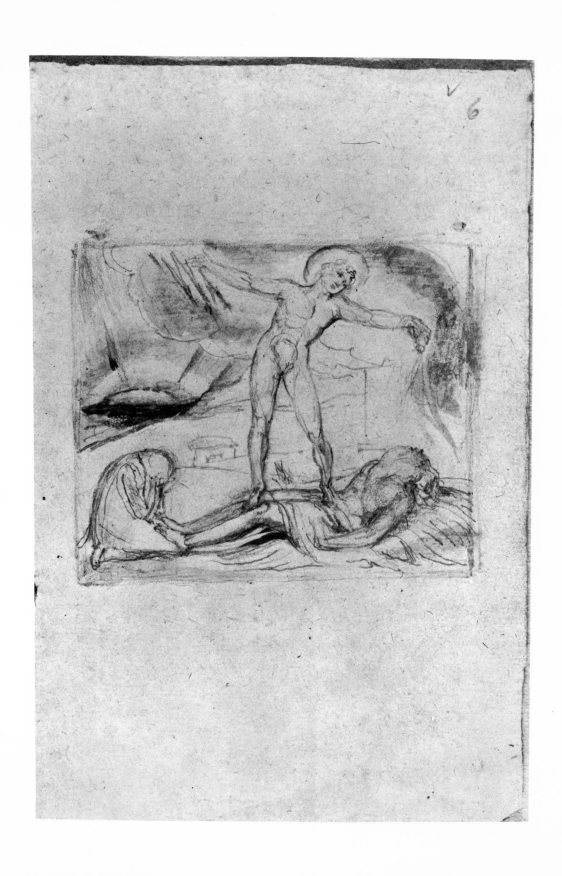

78 When the Morning Stars Sang Together and All the
Sons of God Shouted for Joy

c. 1823; 200 × 135 mm. (Fitzwilliam Museum, Cambridge, England)

A pencil study for no. 14 of the engravings for *Illustrations of the Book of
Job*, 1826. The border decoration is only faintly indicated. Blake has
signed the drawing with a series of symbols, including a hand and an eye.
The title is from *The Book of Job*, xxxviii, 7.

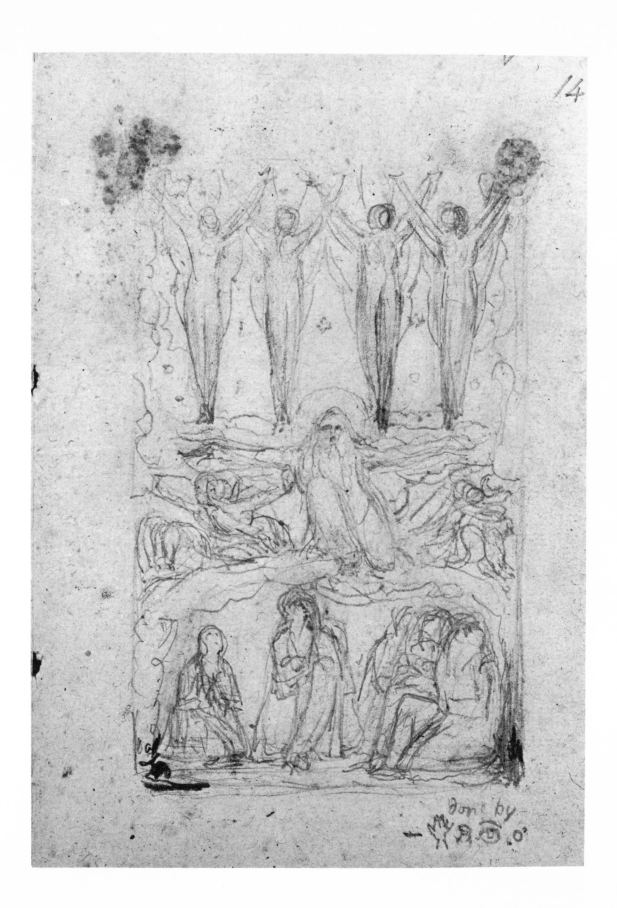

79 Every Man Also Gave Him a Piece of Money (*frontispiece*)

c. 1824; 228 × 177 mm. (Kerrison Preston Collection)

A study in pencil touched with watercolours for the subject of no. 19 of the designs for *Illustrations of the Book of Job*. In the Department of Prints and Drawings at the British Museum there is a similar, though less finished, drawing, but neither was used for the engraving, where the subject is quite differently treated.

80 Job and His Daughters (*opposite*)

c. 1818; 215 × 255 mm. (National Gallery of Art, Washington, D.C., Lessing J. Rosenwald Collection)

A rough sketch for Plate 20 of *Illustrations of the Book of Job*, 1826. There are several versions of the group in pencil, watercolour or tempera. In these Job, surrounded by his three daughters, is usually shown inside a room with frescoes on the walls. In this sketch the sun hangs over the stone on which he is seated, and grazing sheep are indicated on either side.

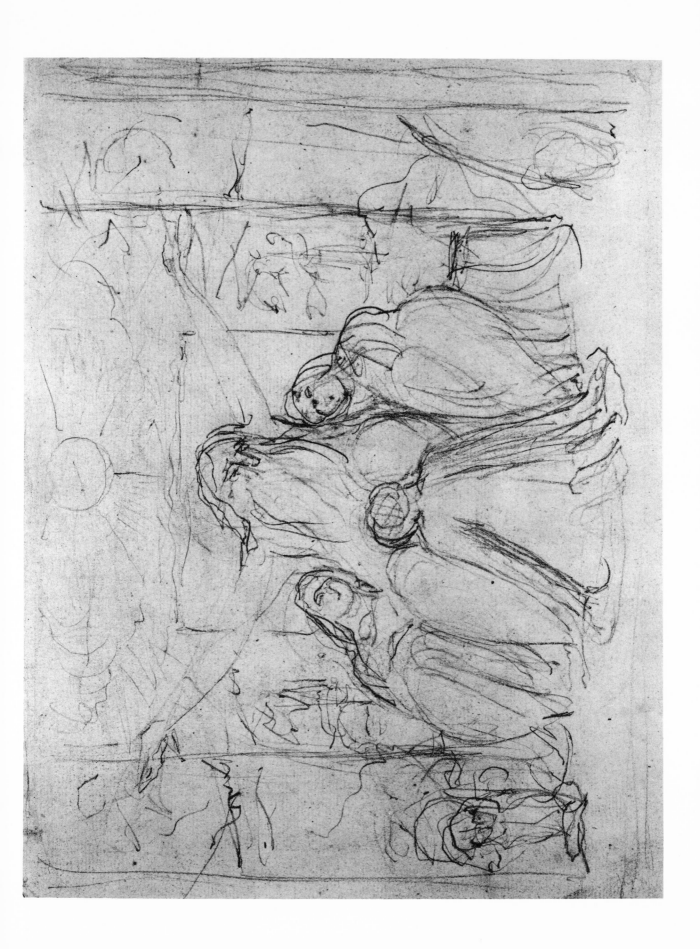

81 Head of an Infant in a Bonnet

c. 1820; 208 × 262 mm. (Private collection, England)

A life study in pencil drawn from an unknown subject, though likely to
have been one of the family of John Linnell. Inscribed: "drawn by William
Blake. vouched by Frederick Tatham."

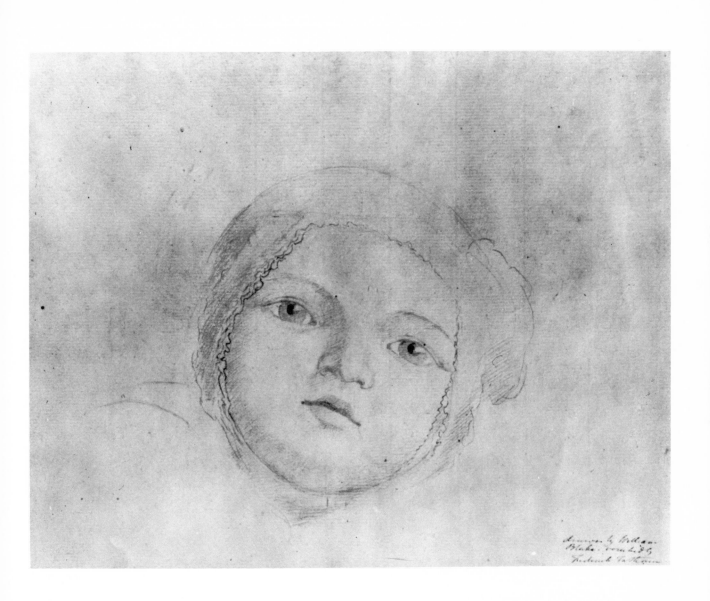

82 Charon, from an Antique

c. 1820 (?); 150 × 190 mm. (Tate Gallery, London)

This careful drawing is inscribed by Frederick Tatham: "Charon by William Blake; copied from something else — not designed by him." The source has not been identified, but it has enough of Blake's character to give it interest. It has no resemblance to the drawing for "Charon" in the sixth design for the Dante series.

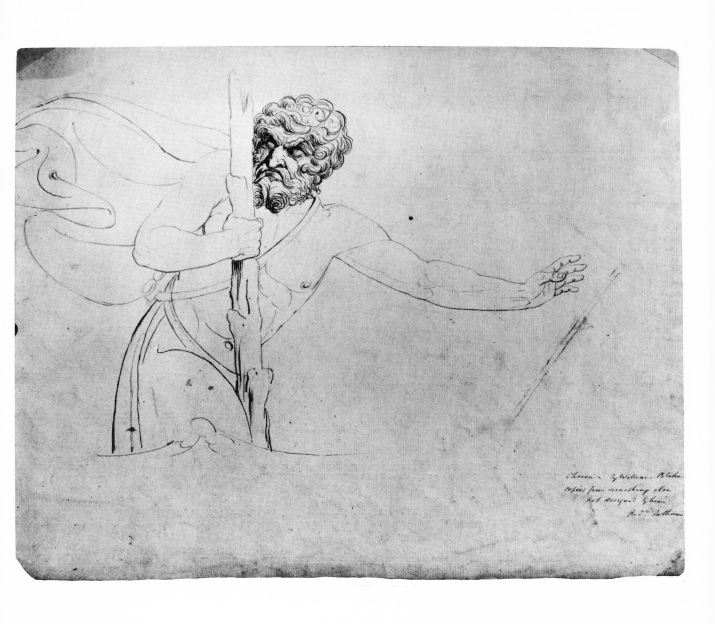

83 Isaiah Foretelling the Destruction of Jerusalem

c. 1821; 123 × 80 mm. (The British Museum, Department of Prints and Drawings)

The subject was drawn on a wood-block and was evidently intended to be the basis for a wood-engraving, but was never executed. Probably it was done about the same time as the wood-engravings for Thornton's *Virgil*, 1821.

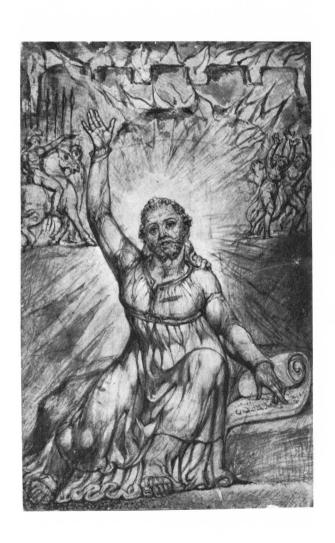

84 The Angels and the Daughter of Man

c. 1822; c. 530 × 370 mm. (National Gallery of Art, Washington, D.C.,
Lessing J. Rosenwald Collection)

One of five drawings illustrating the Ethiopic *Book of Enoch*, published in
English in 1821. Two angels in the form of stars with phallic attributes
descend towards one of the beautiful daughters of man.

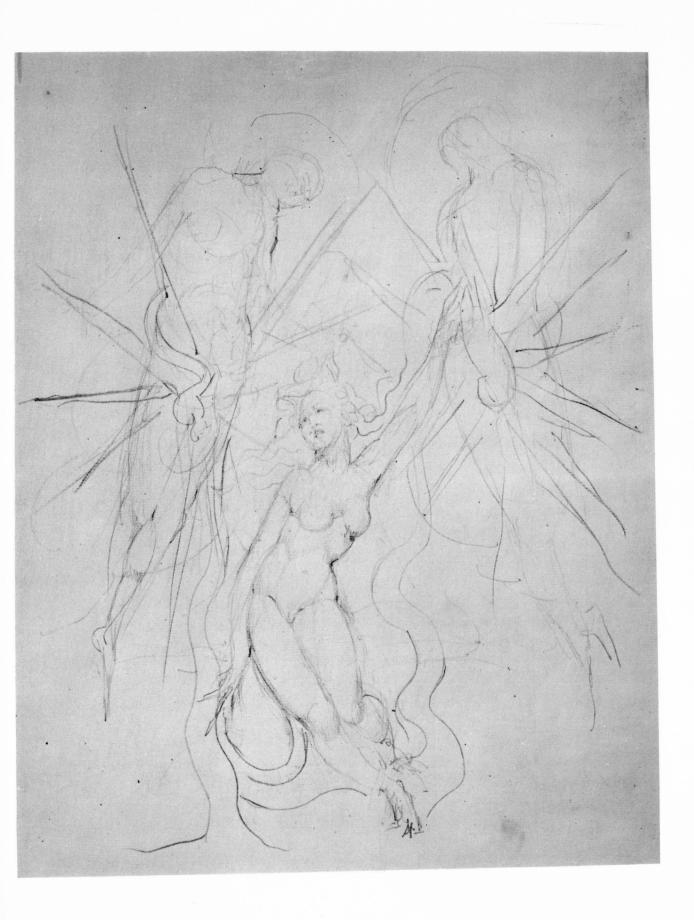

85 Unidentified subject

c. 1826; 196 × 158 mm. (British Museum, Department of Prints and Drawings)

This pencil drawing is in the manner of Blake's latest work, and it may be related to the designs for Dante's *Inferno*, though not identifiable. A nude man on the right is threatened by an "angel," who descends with outstretched arms holding a knife in his right hand. Tassels hang from his arms and ankles, and flames radiate from his head. An indeterminate figure crouches on the ground between them.

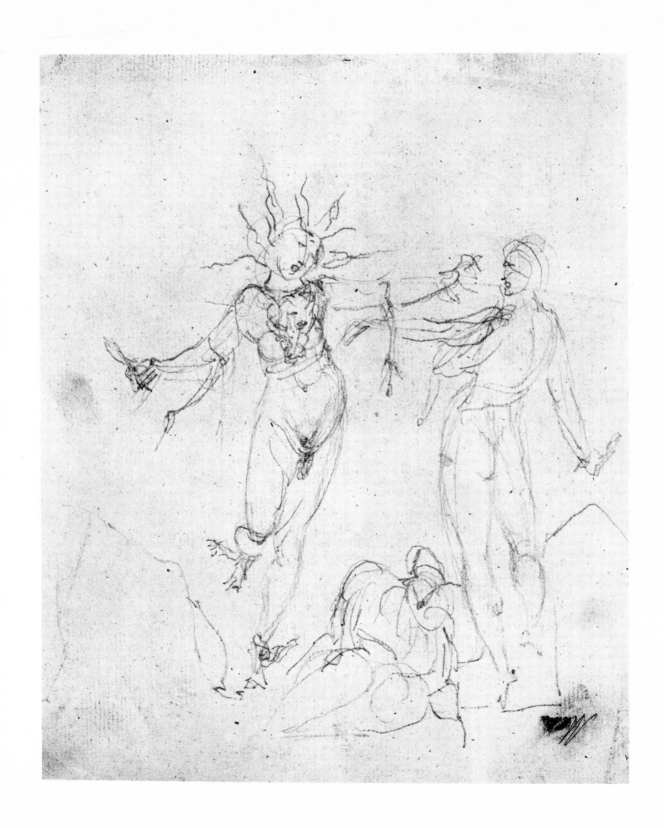

86 Paolo and Francesca

c. 1826; 350 × 230 mm. (Private collection, England)

This vigorous sketch of two lovers embracing is usually related with the loves of Paolo Malatesta and Francesca da Rimini, who appear in "The Circle of the Lustful," the tenth design for the illustrations of Dante's *Inferno*. Blake did not reproduce the effectively contorted figures of the present sketch, but it is probable that he made the drawing with this idea in his mind.

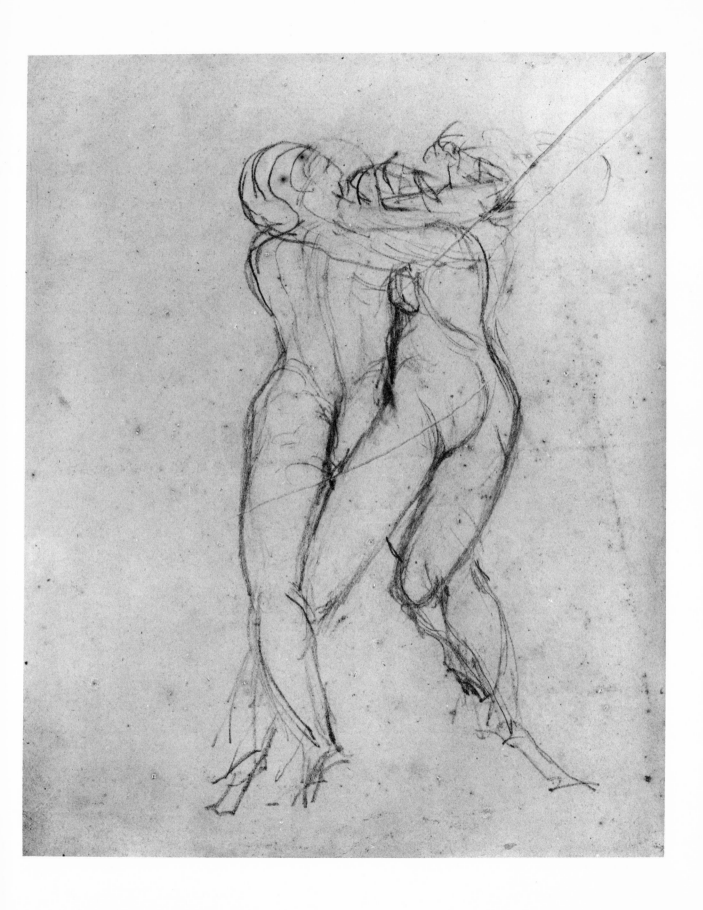

87 Design for Dante's *Divine Comedy*

c. 1826; 228 × 134 mm. (National Gallery of Art, Washington, D.C., Lessing J. Rosenwald Collection)

This rough sketch was certainly intended for the Dante series, though it was not used in this form. It may be a first idea for design no. 10, "The Circle of the Lustful," or possibly for design no. 75, "The Souls of Those Who Only Repented at the Point of Death."

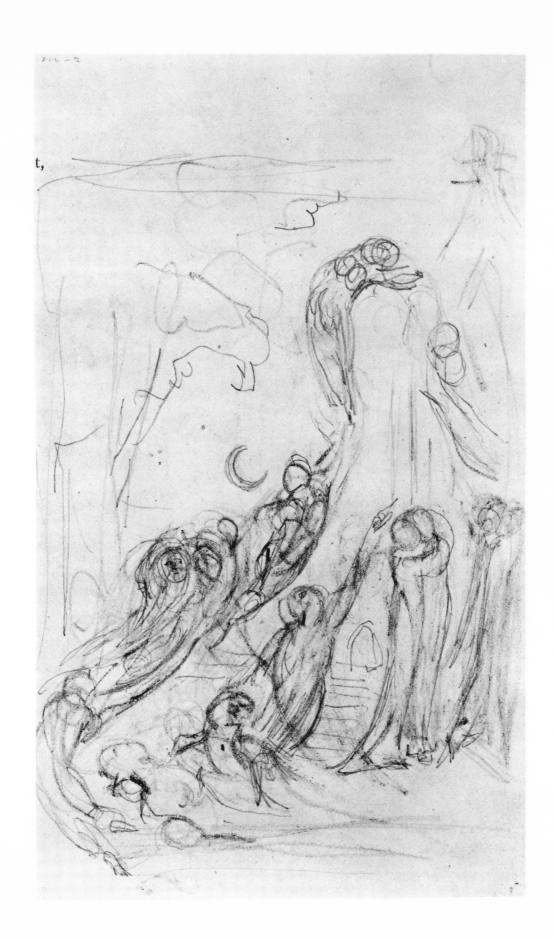

88 The Usurers: Dante's *Inferno*

c. 1826; 242 × 343 mm. (The Fogg Museum of Art, Harvard University)

A pencil study for no. 30 in the Dante series, *Inferno*, canto xvii, lines 34–78; the drawing was not carried any further. Dante, on the left, is talking with the usurers, who are sitting under a rain of fire.

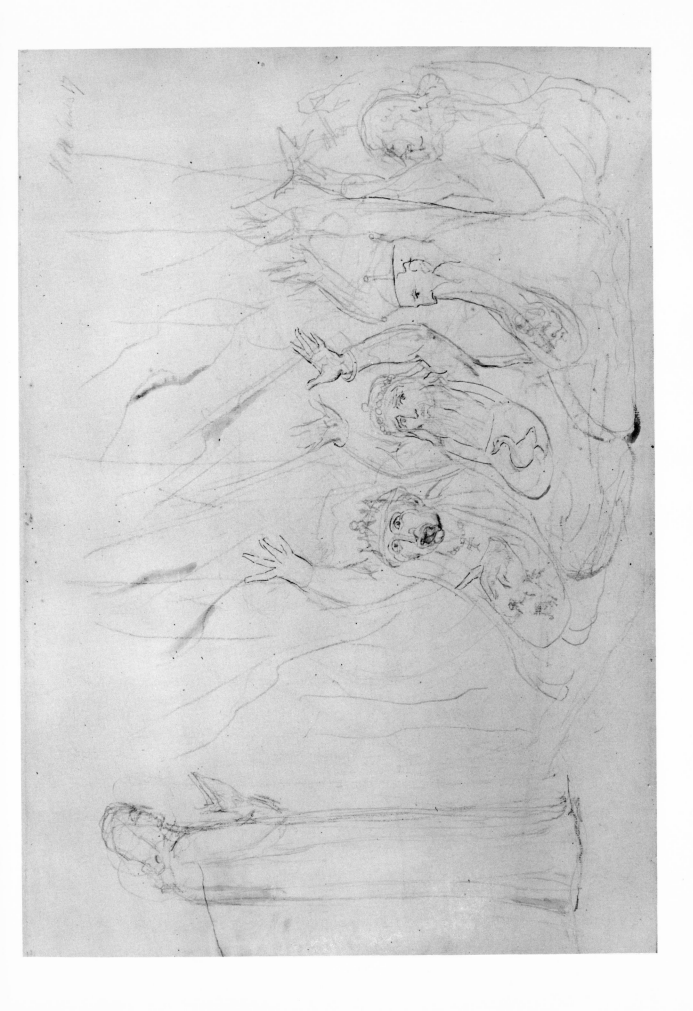

89 The Six-footed Serpent Attacking Brunelleschi:
Dante's *Inferno*

c. 1826; 241 × 327 mm. (Henry E. Huntington Library and Art Gallery,
San Marino, Cal.)

A careful pencil study for the watercolour design no. 51 for Dante's *Divine
Comedy*, illustrating *Inferno*, canto xxv. Also engraved by Blake with minor
changes. Dante and Virgil (left) are watching the Florentine robbers, Angelo
Brunelleschi, Puccio Sciancato and Buoso Donati. The fourth robber,
Cianfa Donati, already transformed into a six-footed serpent, springs onto
Brunelleschi's back and together they are merged into a single monster.

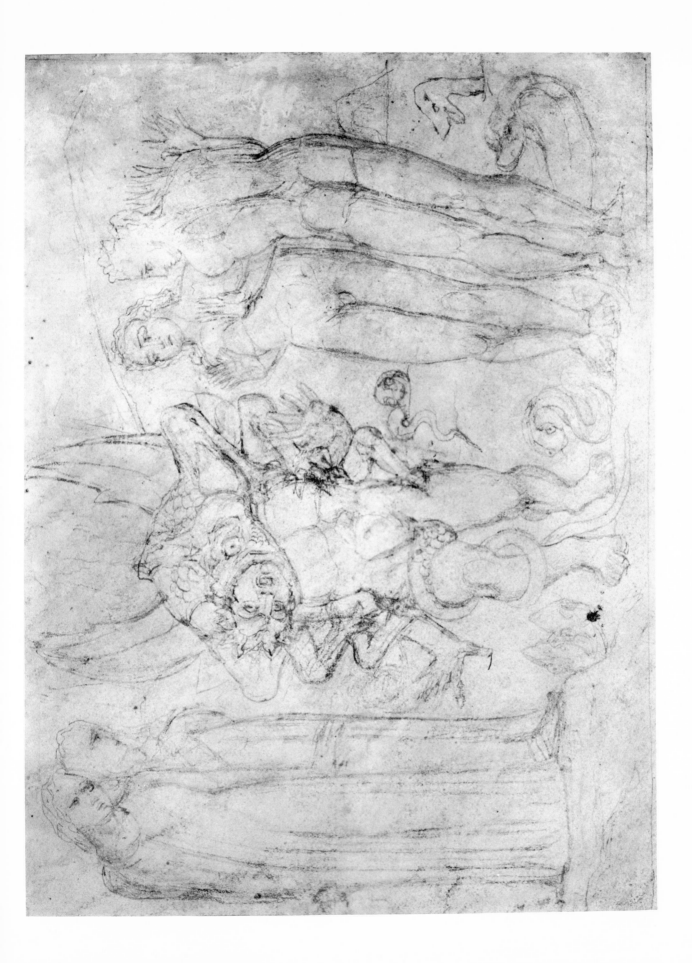

90 Brunelleschi Half Transformed into a Serpent: Dante's *Inferno*

c. 1826; 242 × 178 mm. (Art Institute, Chicago)

A pencil study for the watercolour illustration no. 52 in the series for Dante's *Divine Comedy*, now in the Fogg Museum of Art, Harvard University.

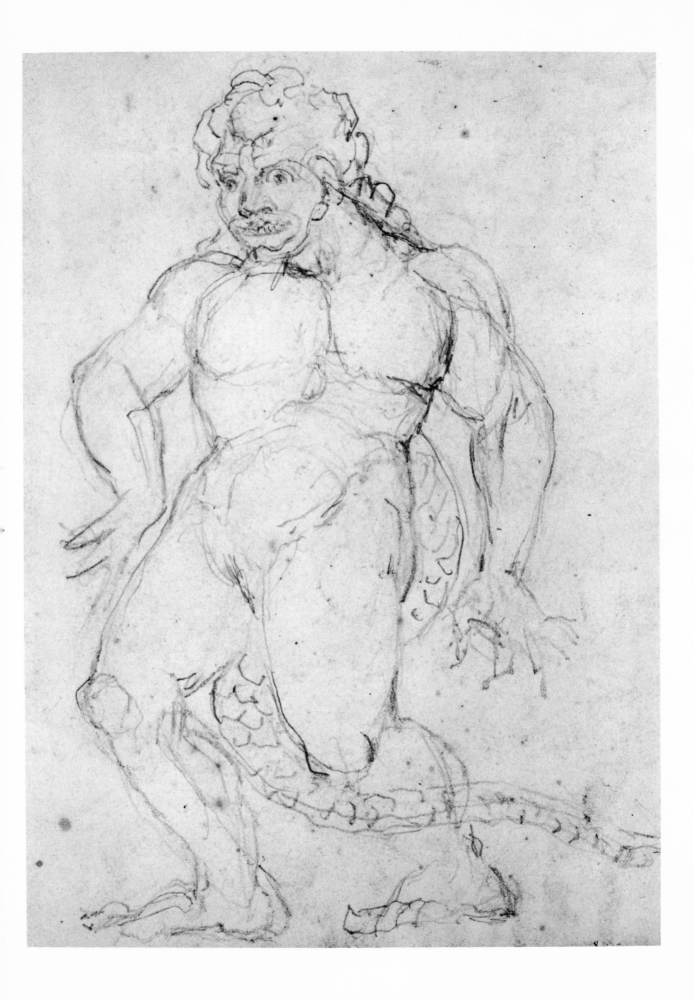

91 An Angel Descending: Dante's *Divine Comedy*

c. 1826; 280 × 400 mm. (Victoria and Albert Museum, London)

This vigorous drawing of a winged figure striding through the starry heavens is a study for "The Angel Descending at the Close of the Circle of the Proud," design no. 82 in the Dante series (*Purgatorio*, XII, 79 ff.). In the finished design the angel's left foot is in the position shown by the feet roughly drawn in the sketch below his robe.

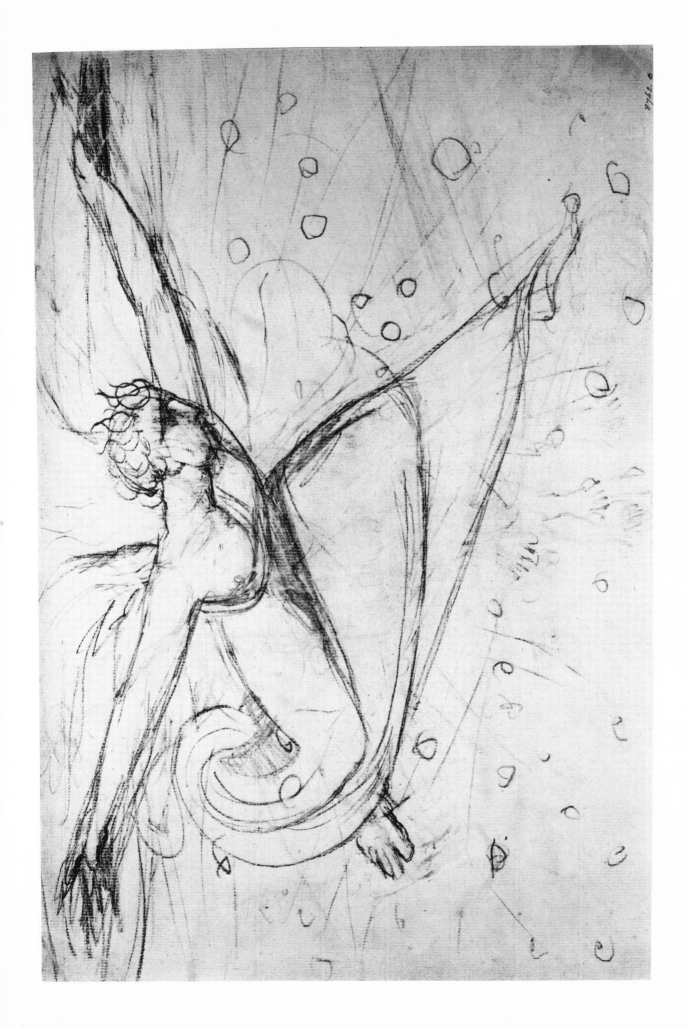

92 Design for Dante's *Divine Comedy*

c. 1826; 222 × 115 mm. (The Pierpont Morgan Library, New York)

This preliminary sketch appears to belong to the Dante series, though it cannot be identified among the more finished drawings. The figure on the right turning away in pity is presumably Dante, but, if so, Virgil is not shown. Blake has used, as he often did, a sheet of paper remaining from the proofs of Hayley's *Ballads*, 1802, this one carrying a catchword, "With" (page **20** of the *Ballads*).

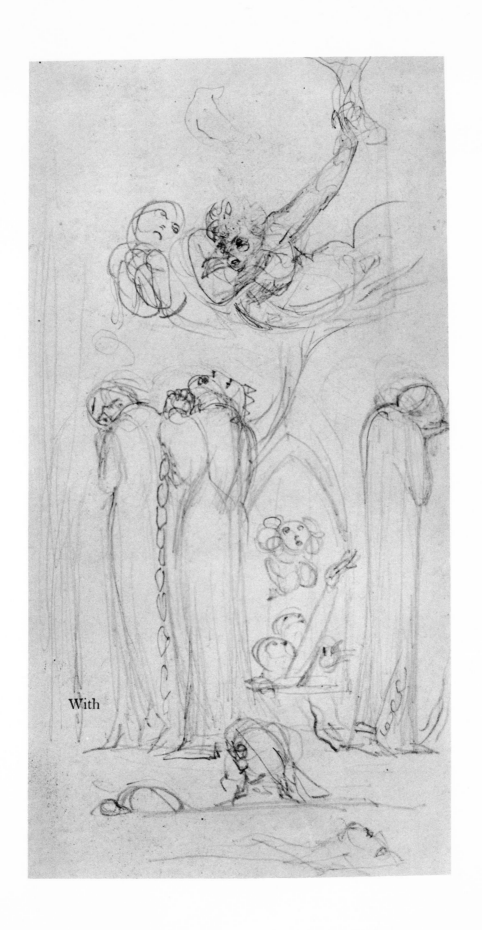

With